LEE MILLER

AN EXHIBITION OF PHOTOGRAPHS

1929 - 1964

Swindon College

Exhibition Curator
Jane Livingston

CIAF
_ 5
California/International Arts Foundation

2

Copyright © 1991 California/International Arts Foundation

Photographs © 1991 The Lee Miller Archives
Burgh Hill House, Chiddingly
East Sussex BN8 6JF, England
Telephone: 0825 872-691 Fax: 0825 825-733

Published By the California /International Arts Foundation
2737 Outpost Drive, Los Angeles, California 90068.

Designed by Gerry Rosentswieg, The Graphics Studio, Los Angeles.
Printed in the USA by Gardner Lithograph, Buena Park, California

Library of Congress Catalog Card Number 91-071408
ISBN Number 0-917571-10-X

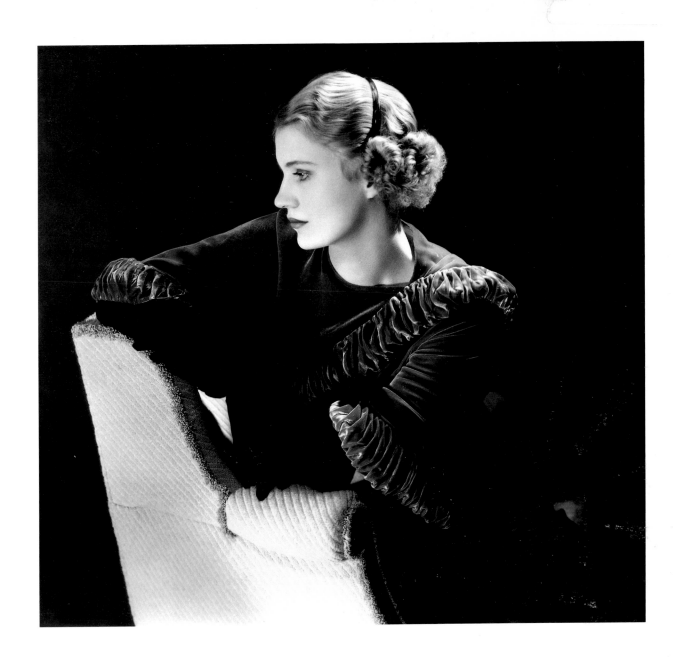

Cover: Lee Miller, Self Portrait, 1932, Detail
Above: Lee Miller, Self Portrait, 1932.
　　　Lee Miller Archives

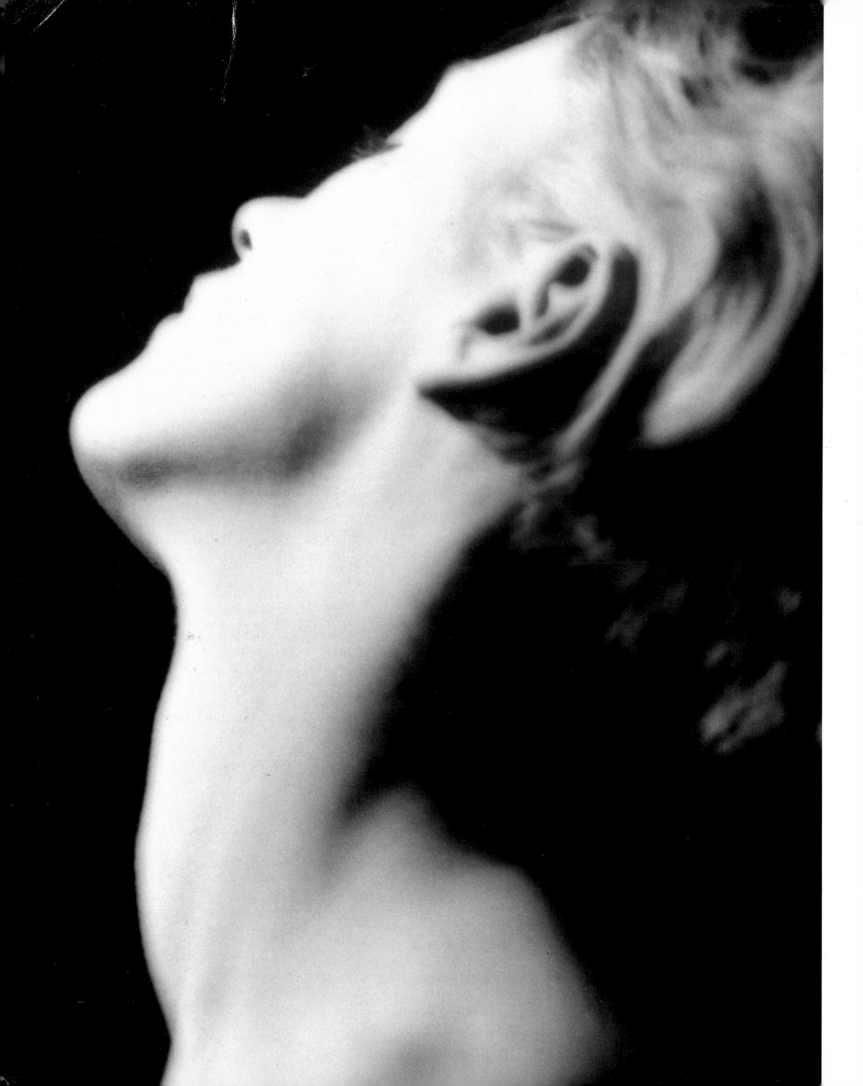

LEE MILLER

A Chronology

By Antony Penrose

Man Ray, "Neck," a portrait of Lee Miller which Man Ray later used as inspiration for his painting "Le Logis de l'Artist," 1929. Lee Miller Archives

	
1907	Born Poughkeepsie, New York, on 23 April to Frances and Theodore Miller. Brother John born 1905. Brother Erik born 1910.
1925	30 May, departs for Paris with chaperon. Attends L'Ecole Medgyes pour la Technique du Théâtre.
1926	Returns to New York and enrolls in Art Students League.
1927	Discovered by Condé Nast. Portrait of her by George Lepape appears on front cover of *Vogue*, March 1927. Photographed by Steichen, Genthe, Muray, with numerous appearances in magazines.
1929	Departs for Paris, then to Florence and Rome to study art. Returns to Paris, meets Man Ray and becomes his student, model and lover.

With Man Ray discovers solarization photographic process. |
| 1930 | Establishes herself as a photographer with her own studio at 12 Rue Victor Considerante.

Stars in Jean Cocteau's film "*Blood of a Poet*". |
| 1931 | Visits London to do stills work at Elstree Studios for 1 July issue of *The Bioscope* and photographs sports clothes for June issue of *Vogue*.

Exhibits at Group Annuel des Photographes, Galerie de la Pleiade, Paris.

Meets Aziz Eloui Bey. |
| 1932 | 20 February-11 March, first exhibition at Julien Levy Gallery, New York, "*Modern European Photography*".

Lee Miller leaves Man Ray and closes her studio, returns in November to New York.

30 December-25 January. 2nd exhibition at Julien Levy Gallery, shared with artist Charles Howard.

On arrival in New York sets up her own studio at 8 East 48th Street. |
| 1933 | Meets and photographs John Houseman, Virgil Thompson, Joseph Cornell, Gertrude Lawrence and other celebrities.

Photographs cast of John Houseman's landmark production of Gertrude Stein's Surrealist opera "*Four Saints in Three Acts*". |
| 1934 | 19 July, marries Egyptian businessman Aziz Eloui Bey and goes to live in Egypt. |
| 1936 | Resumes photographing for pleasure on trips into the desert. |

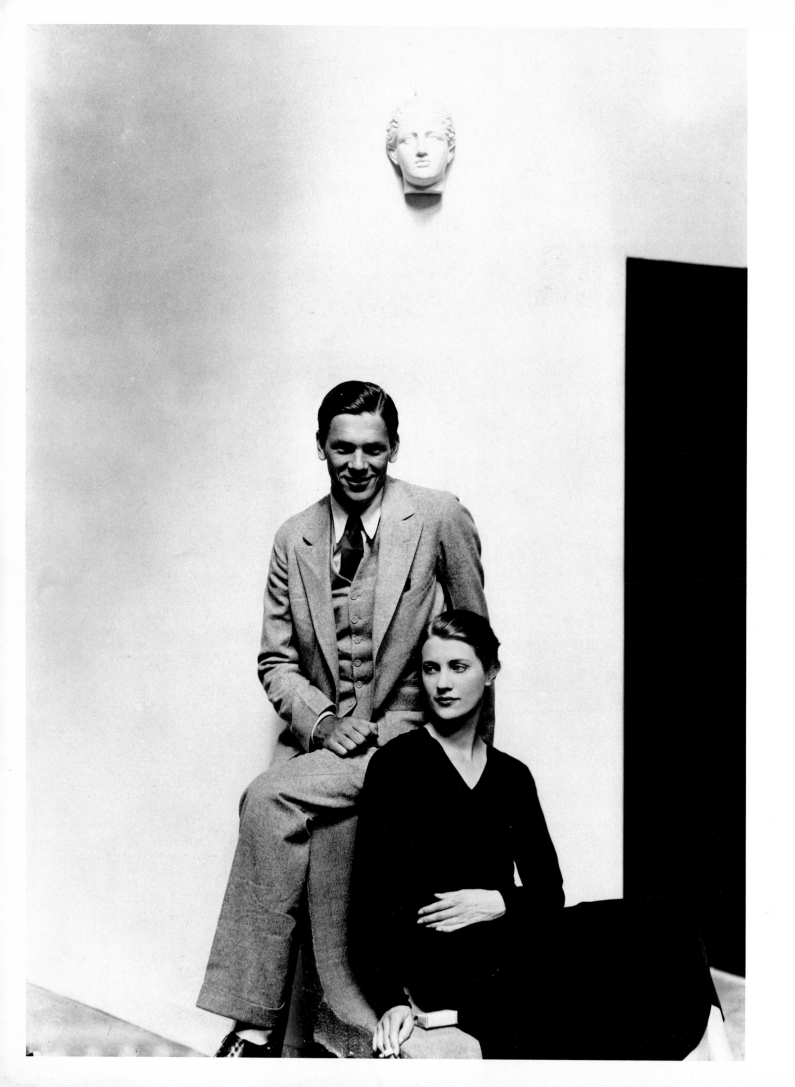

LEE MILLER
A Chronology

1937 — Early summer, goes to Paris and meets Roland Penrose. Travels with him to England and then to Mougins, France, to holiday with Man Ray, Picasso, Eileen Agar and the Paul Eluards.

1938 — Meets Roland Penrose in Athens, and travels with him through the Balkans photographing village life in remote areas. Returns via Beirut.

1939 — Roland Penrose visits Lee Miller in Egypt, and they travel to various oasis villages.

2 June, parts amicably from Aziz Eloui Bey and sails to England and Roland Penrose. They travel to the south of France to visit Max Ernst and Leonora Carrington, then return to England at the outbreak of war.

1940 — Joins staff of *Vogue*. Photographs fashion and scenes of the Blitz, later to be used in "*Grim Glory; Pictures of Britain under Fire*", published in Britain and the United States.

1942 — 30 December, becomes accredited as U.S. Forces War Correspondent.
Photographs for her book "*Wrens in Camera*".

1944 — First photo-journalism article published on Edward R. Murrow in *Vogue*, followed by "Unarmed Warriors" in September and "St. Malo" in October.

Publishes further *Vogue* stories:

"The Way Things are in Paris" (November)
"Loire Bridges" (November)
"Players in Paris" (December)

1945 — More *Vogue* stories were:

"The Pattern of Liberation" (January)
"Brussels-More British than London" (February)
"Colette" (March)
"Through the Alsace Campaign" (April)
"Scales of Justice" (June)
"Germany-the war that is won" (June)
"Hitleriana" (July)
"In Denmark Now" (July)

Vienna, covers children dying in hospital.

1946 — Budapest, covers plight of deposed aristocrats, execution of Bardossy, rural areas such as Mezokovesd, and celebrities such as Strobol, Szentgyorgi, etc.

On to Bucharest, Romania, where she photographs Queen and Crown Prince.

In the spring returns home via Paris to a heroine's welcome from *Vogue* staff.

George Hoyningen-Huene, Erik Miller and Lee Miller, Paris, 1930. Lee Miller Archives

Travels to New York with Roland Penrose as guest of *Vogue*.

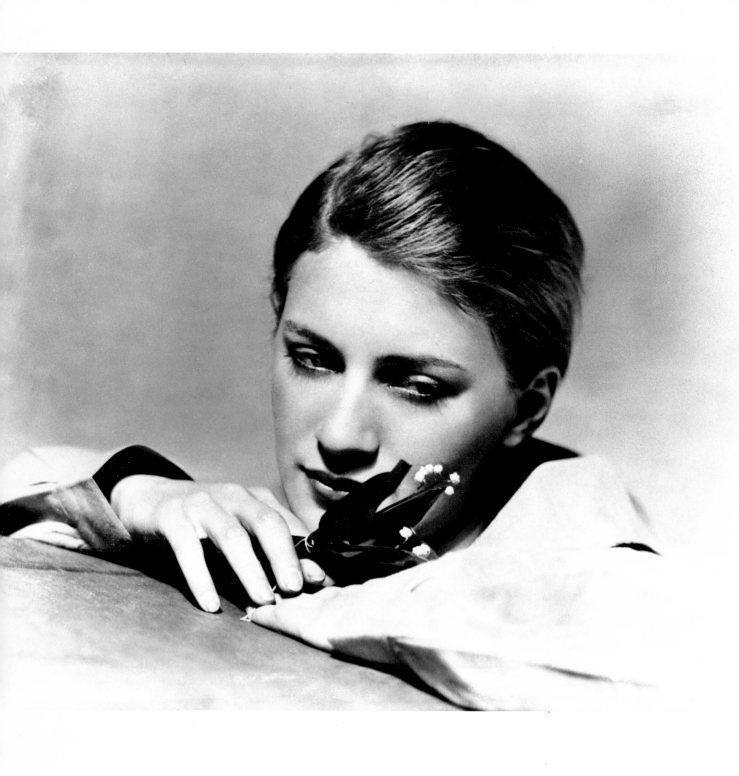

Horst P. Horst, Lee Miller, Paris,
c. 1930. Lee Miller Archives

LEE MILLER

A Chronology

1946	Photographs Isamu Noguchi.
	Travels with Roland Penrose to Arizona to visit Max Ernst and Dorothea Tanning, and to Los Angeles to visit her brother Erik and his wife Mafy and Man Ray and Juliette Browner.
	Returns to England.
1947	Discovers she is pregnant while on assignment in St. Moritz.
	Lee Miller and Roland Penrose marry on 3 May.
	9 September, son Antony born. Writes on the experience for April 1948 issue of *Vogue*.
1948	Covers Venice Biennale for August *Vogue*.
1949	Writes about the Institute of Contemporary Art's exhibition, "Forty Thousand Years of Modern Art" for January *Vogue*.
1951	Writes on exhibition covering Picasso's birthday for November Vogue.
1953	Writes and photographs article for July Vogue called "Working Guests" about life on the Penrose farm in Sussex.
1954	Photographs for Roland Penrose's book "*Picasso, His Life and Work*".
1955	Exhibits in "*The Family of Man*", Museum of Modern Art, New York (and world tour).
1966	Roland honored by Queen Elizabeth and becomes Sir Roland Penrose. Lee becomes Lady Lee Penrose.
	Articles about Lee's culinary expertise appear in *Vogue*, *Studio International*, and *House and Garden*.
	Travels extensively with Roland Penrose to Japan, Spain, etc.
1973	Photographs Antoni Tapies for Roland Penrose's biography of him.
	July, guest of Lucien Clergue at the Arles Photo Festival, deputizing for Man Ray.
	Exhibits in "*Photography from the Julien Levy Collection*", Art Institute of Chicago.
	Diagnosed as having cancer.
1977	Exhibits in "*The History of Fashion Photography*", organized by the International Museum of Photography at George Eastman House, Rochester, New York.
	Dies in Sussex, July 27.

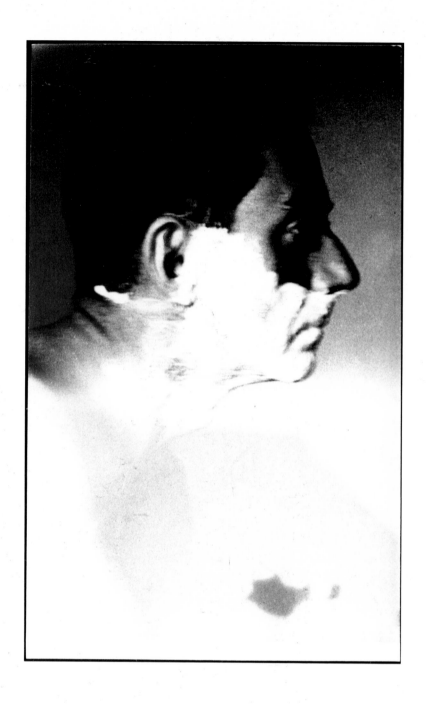

Lee Miller, Man Ray Shaving, c. 1929.
Lee Miller Archives

Lee Miller, Nude Bent Forward, Paris,
c. 1931. The Art Institute of Chicago;
The Julien Levy Collection

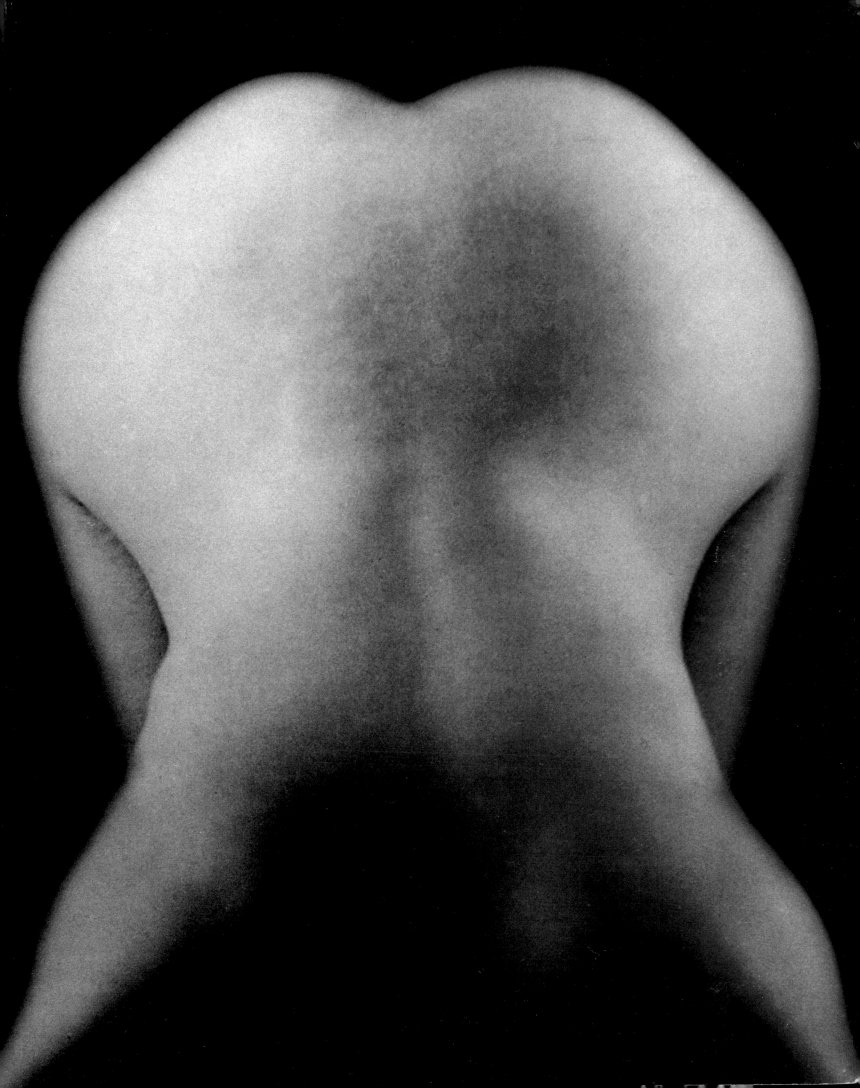

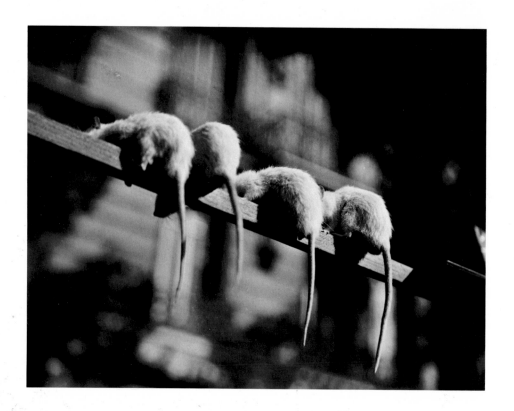

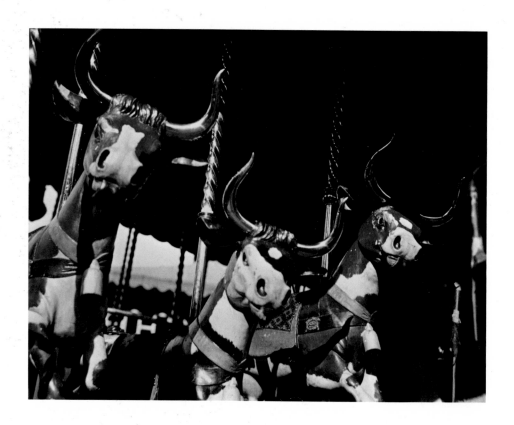

Lee Miller, Rat Tails, c. 1930.
Lee Miller Archives

Lee Miller, Carousel Cows, c. 1930.
Lee Miller Archives

Lee Miller, Ironwork, Paris, c. 1929.
The Art Institute of Chicago; The Julien
Levy Collection

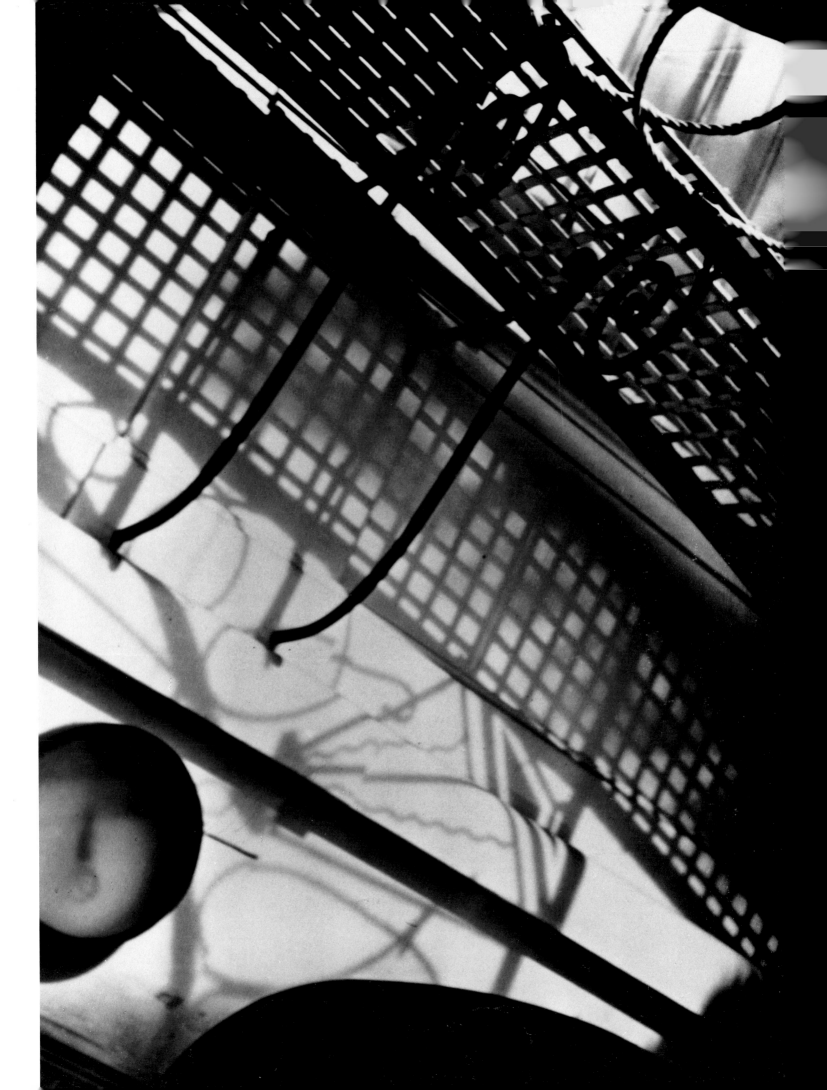

14

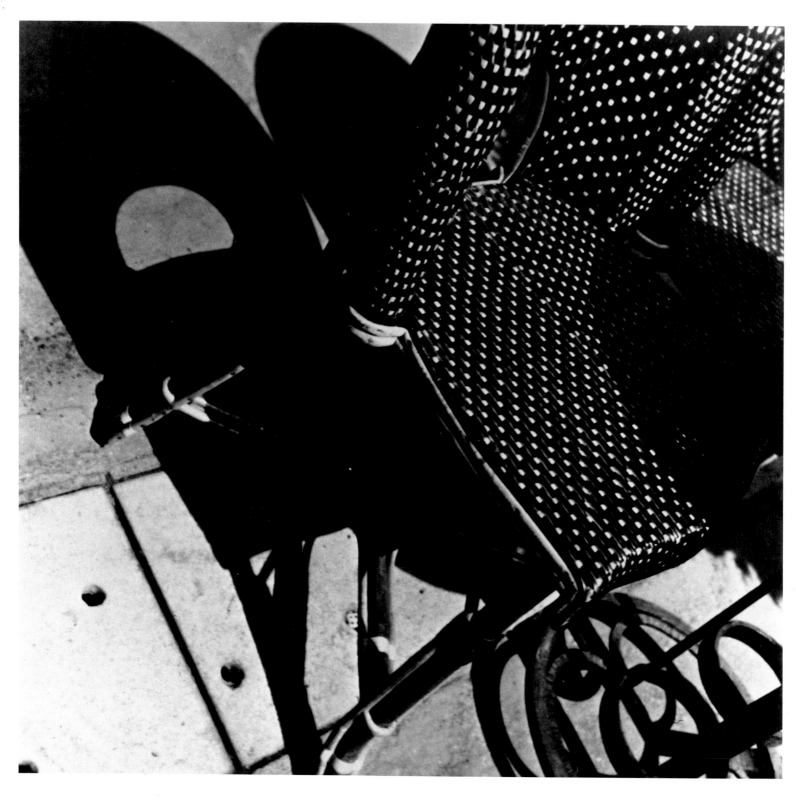

Lee Miller, Chairs, Paris, c. 1929.
The Art Institute of Chicago;
The Julien Levy Collection

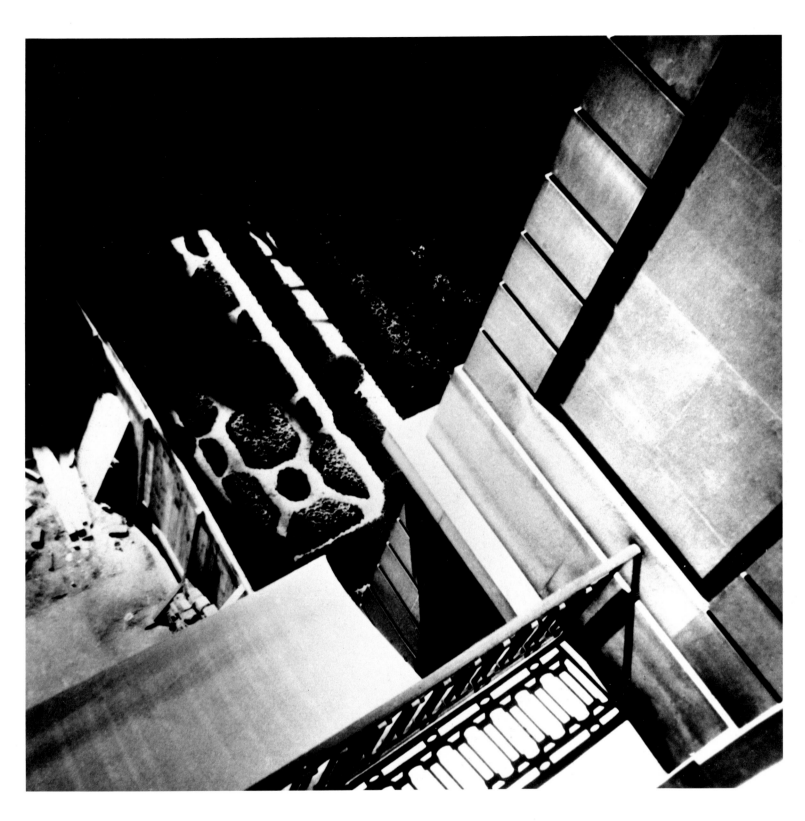

Lee Miller, Architectural View, Paris,
c. 1929. The Art Institute of Chicago;
The Julien Levy Collection

Lee Miller, Unknown Woman, Solarized
Portrait, 1930. Lee Miller Archives

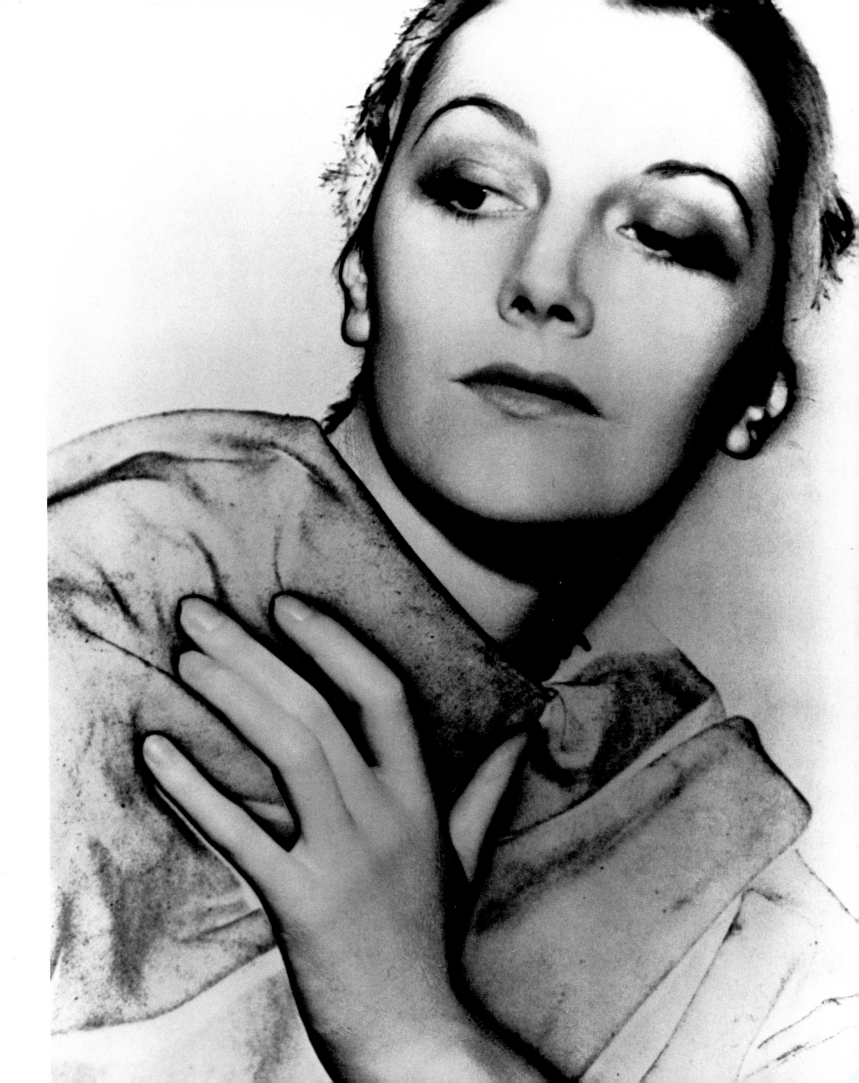

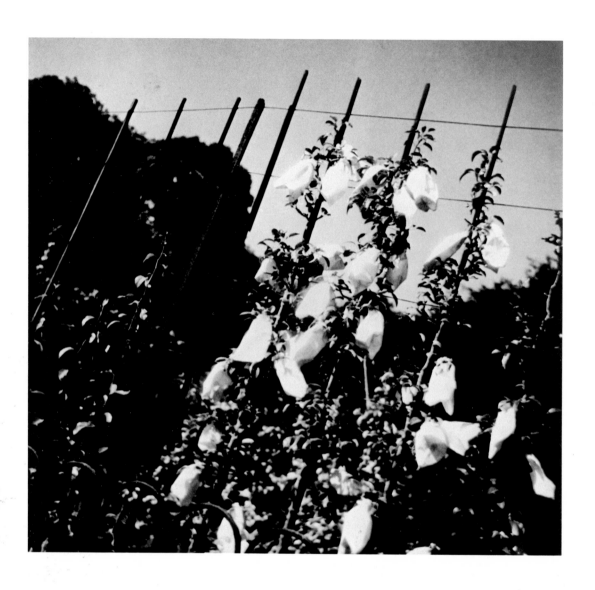

Lee Miller
Pollination Experiment
Paris, c. 1930
Lee Miller Archives

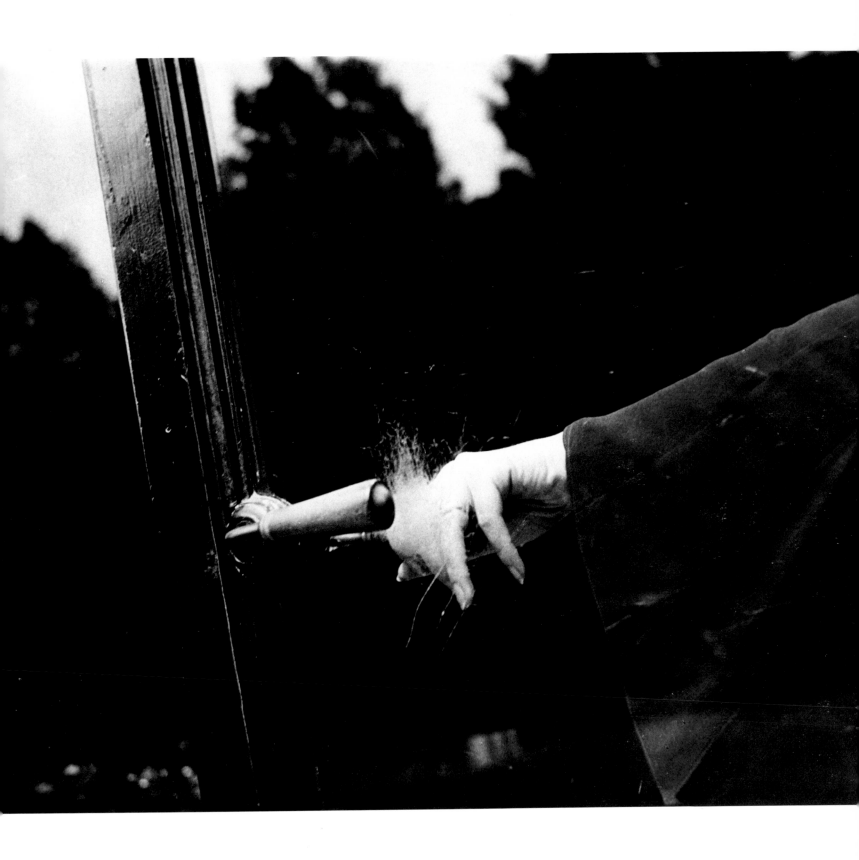

Lee Miller, "Exploding Hand," c. 1930.
Lee Miller Archives

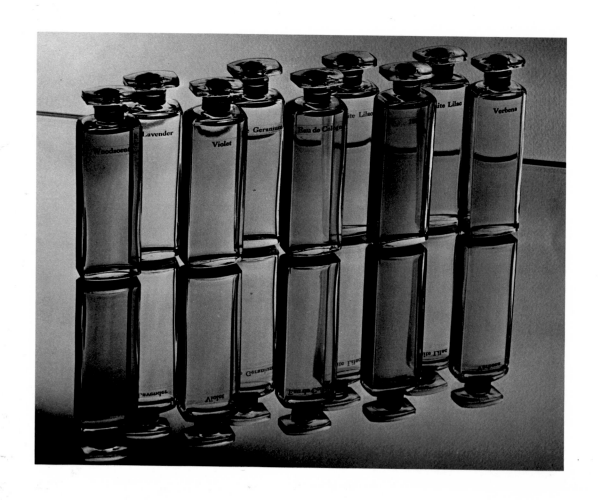

Lee Miller, Scent Bottles, New York,
1933. Lee Miller Archives

Lee Miller, Sculpture in Window,
Paris, c. 1929.
The Art Institute of Chicago;
The Julien Levy Collection

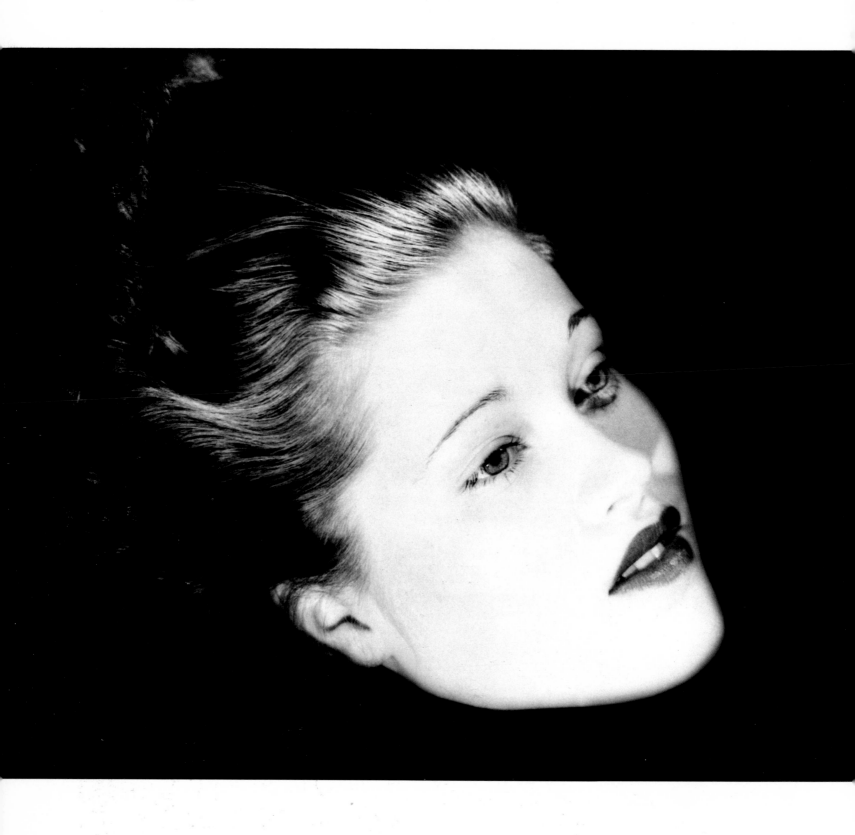

Lee Miller, Floating Head, Portrait of
Mary Taylor, New York, 1933.
Lee Miller Archives

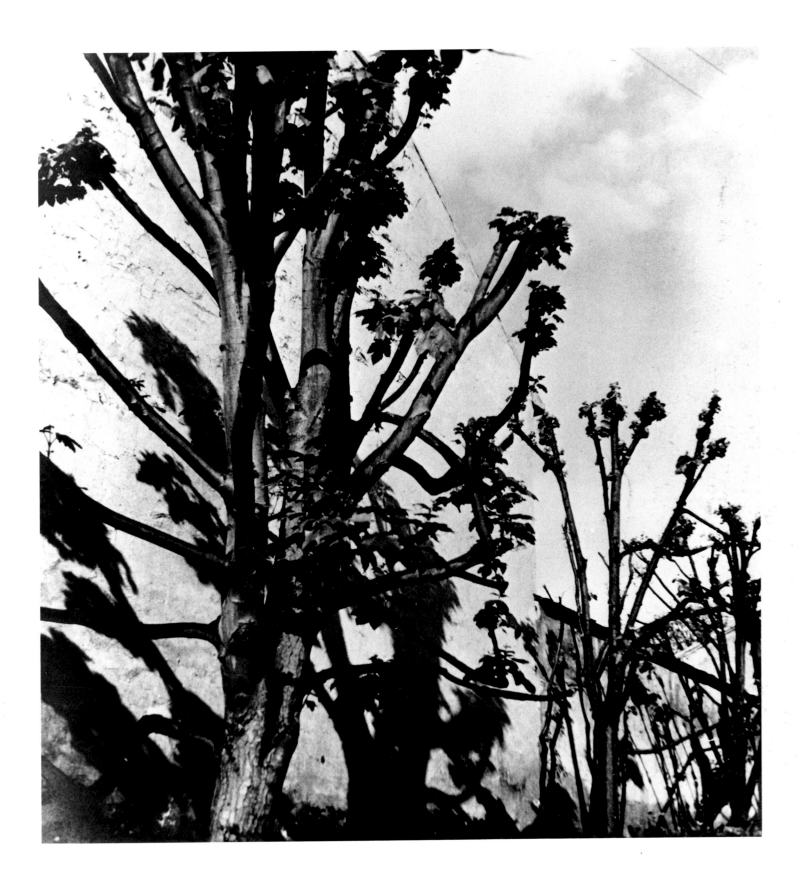

Lee Miller, Untitled (Trees and Shadows),
c. 1929. The Art Institute of Chicago;
The Julien Levy Collection

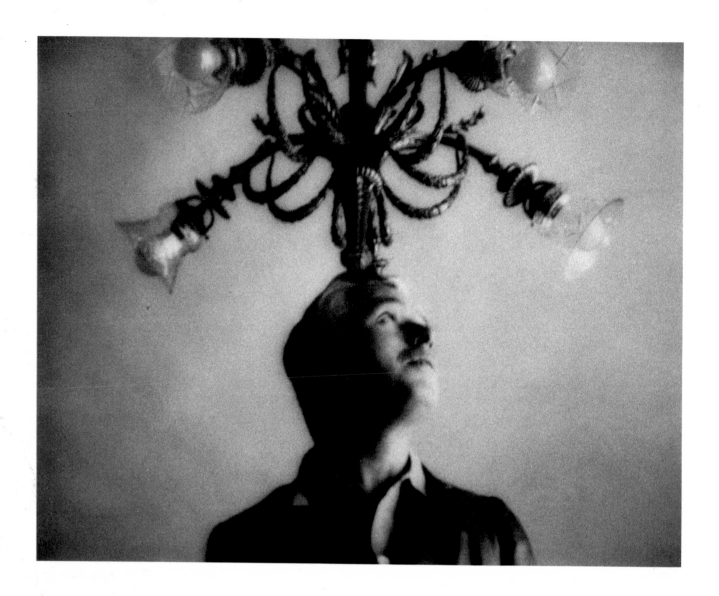

Lee Miller
Charlie Chaplin
c. 1930
Rosalind and Melvin Jacobs

Lee Miller, Man Ray, 1931.
Lee Miller Archives

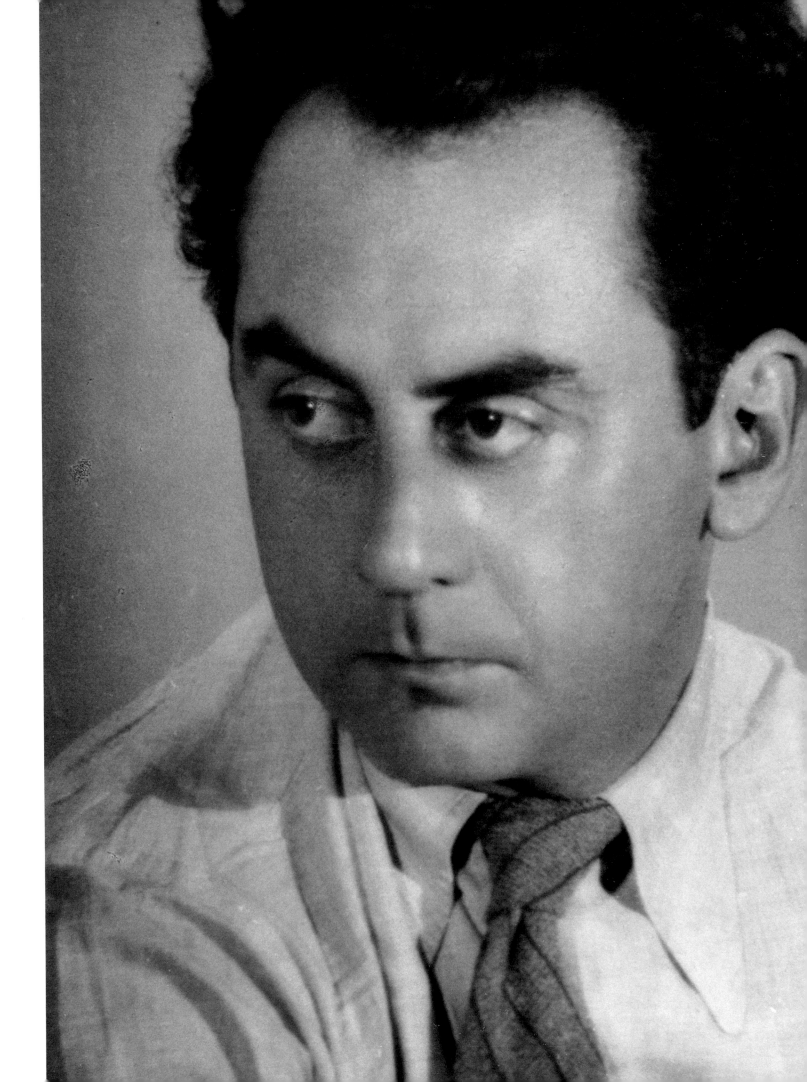

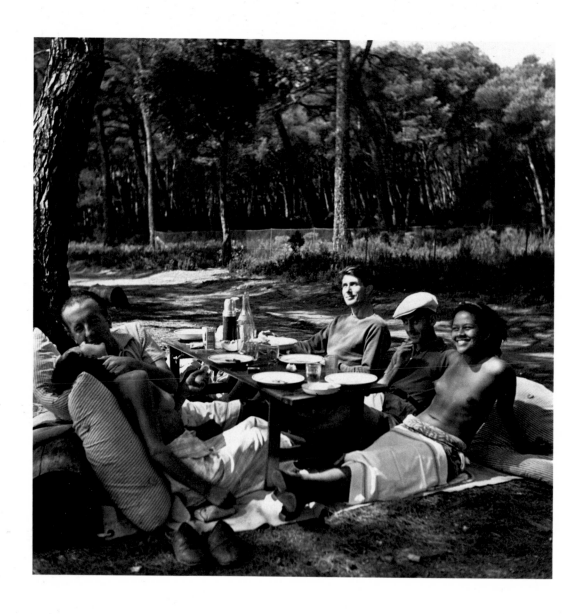

Lee Miller, Picnic (L to R: Paul and
Nusch Eluard, Roland Penrose, Man Ray
and Ady), Mougins, France, 1937.
Lee Miller Archives

Lee Miller, Portrait of Space, near
Siwa, 1937. Lee Miller Archives

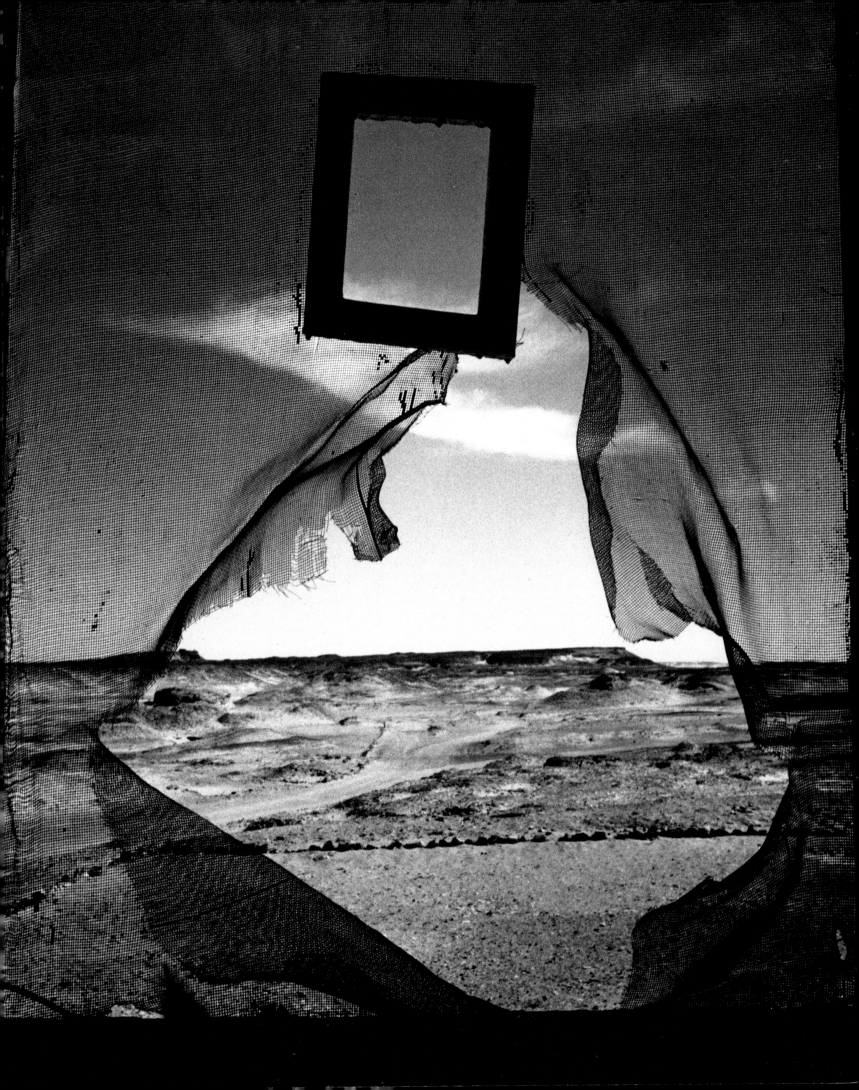

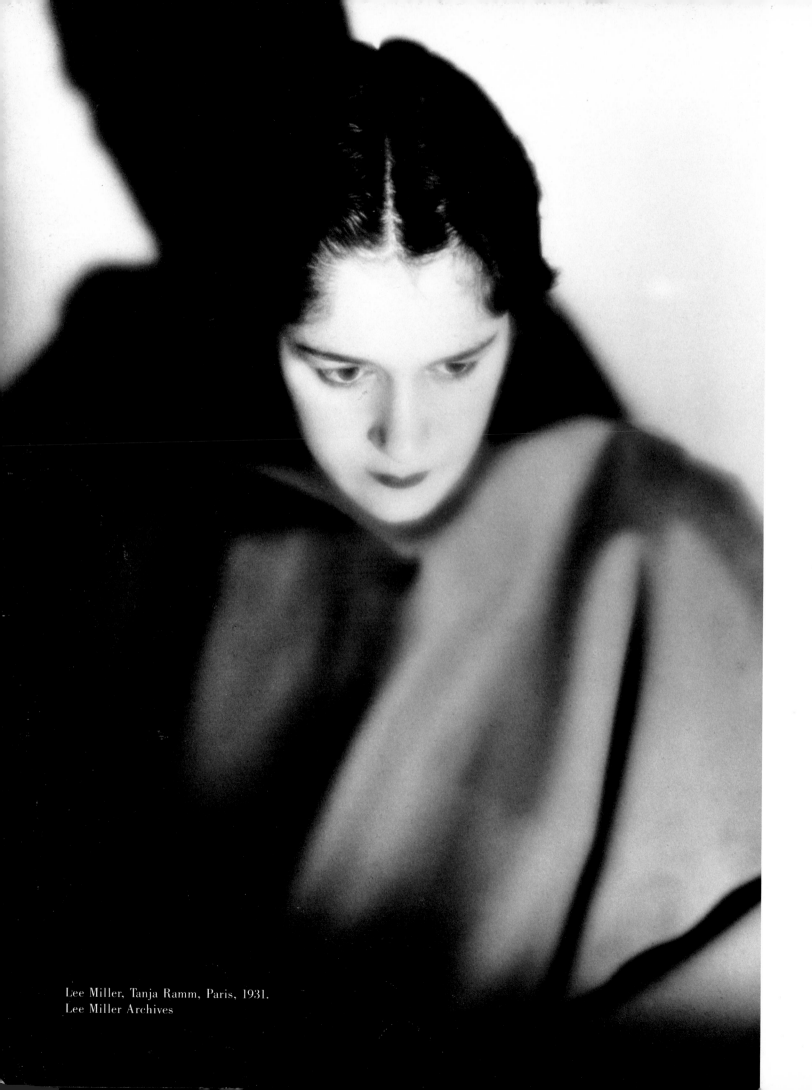

Lee Miller, Tanja Ramm, Paris, 1931.
Lee Miller Archives

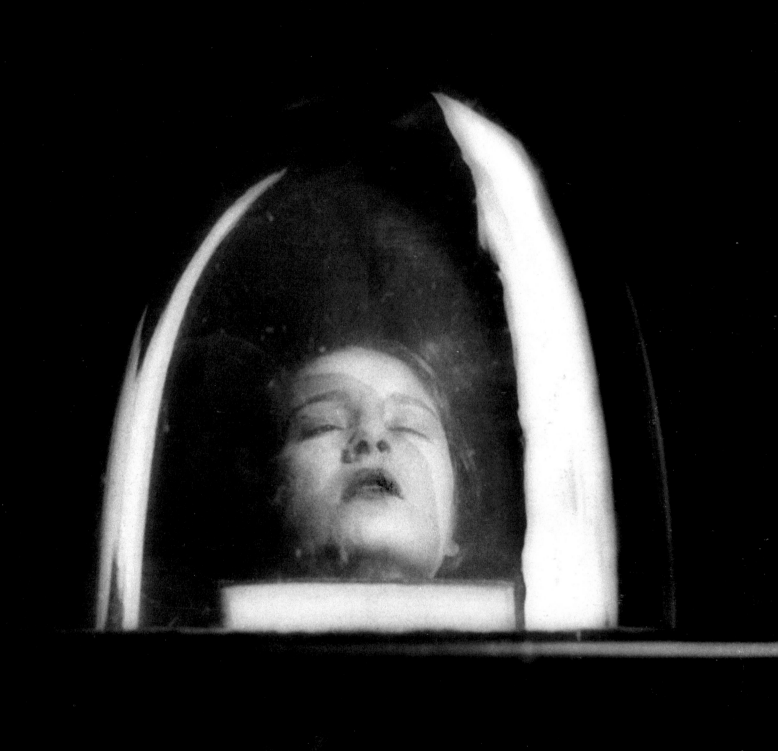

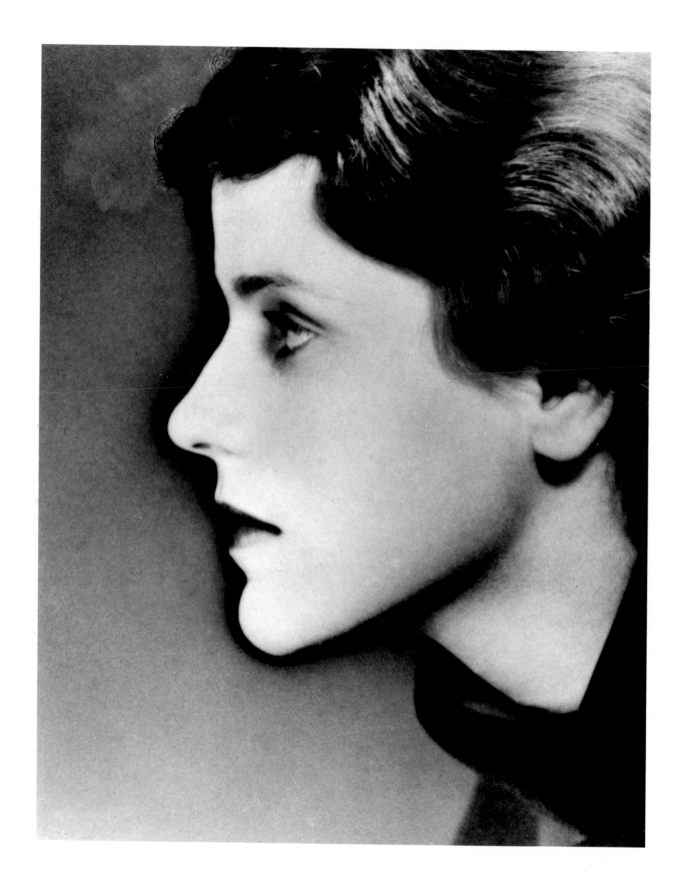

Lee Miller, Dorothy Hill, Solarized
Portrait, New York, 1933. Lee Miller Archives

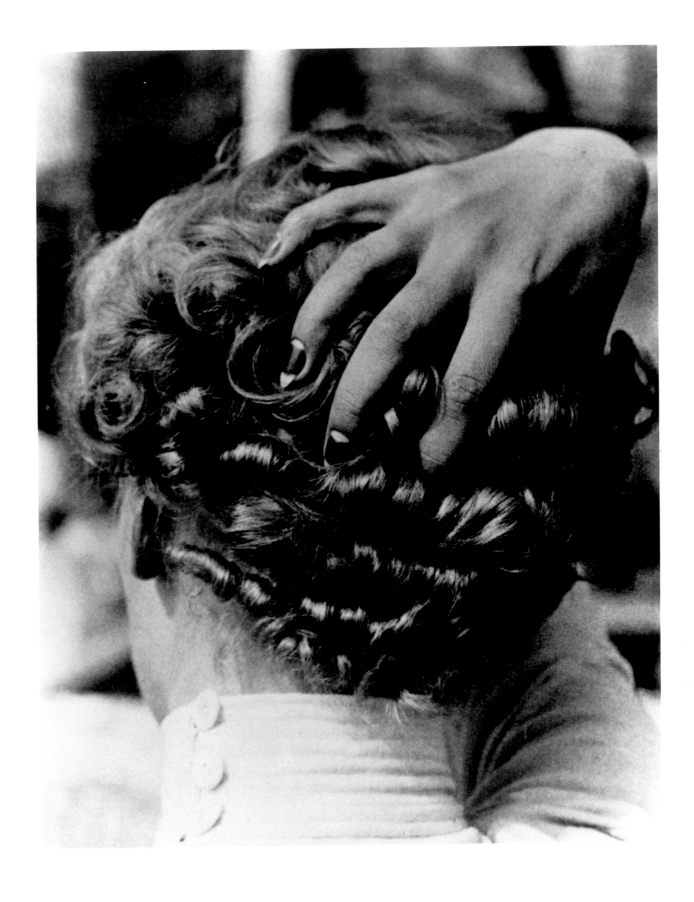

Lee Miller, Woman with Hand on Head,
Paris, 1931. The Art Institute of Chicago;
The Julien Levy Collection

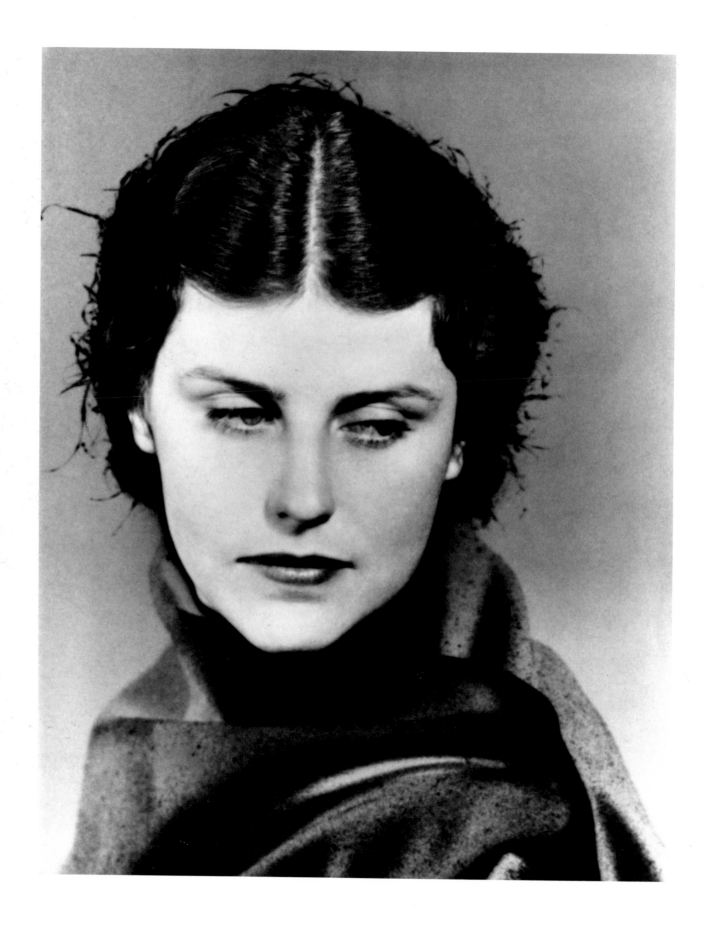

Lee Miller, Dorothy Hill, Solarized Portrait,
New York, 1933. Lee Miller Archives

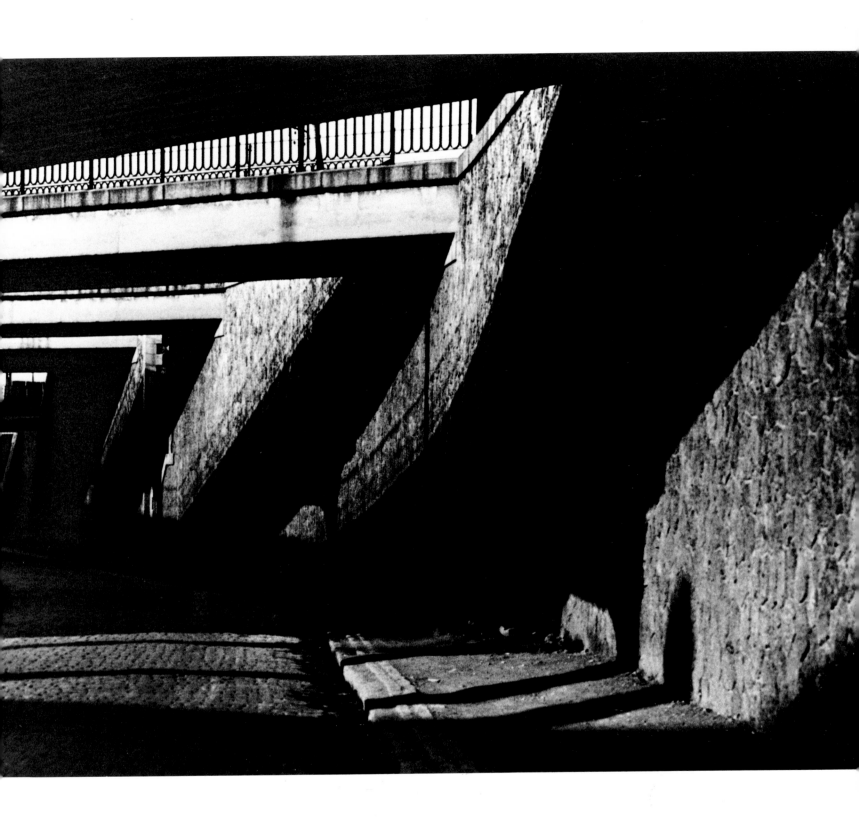

Lee Miller, Walkway, Paris, c. 1929.
The Art Institute of Chicago;
The Julien Levy Collection

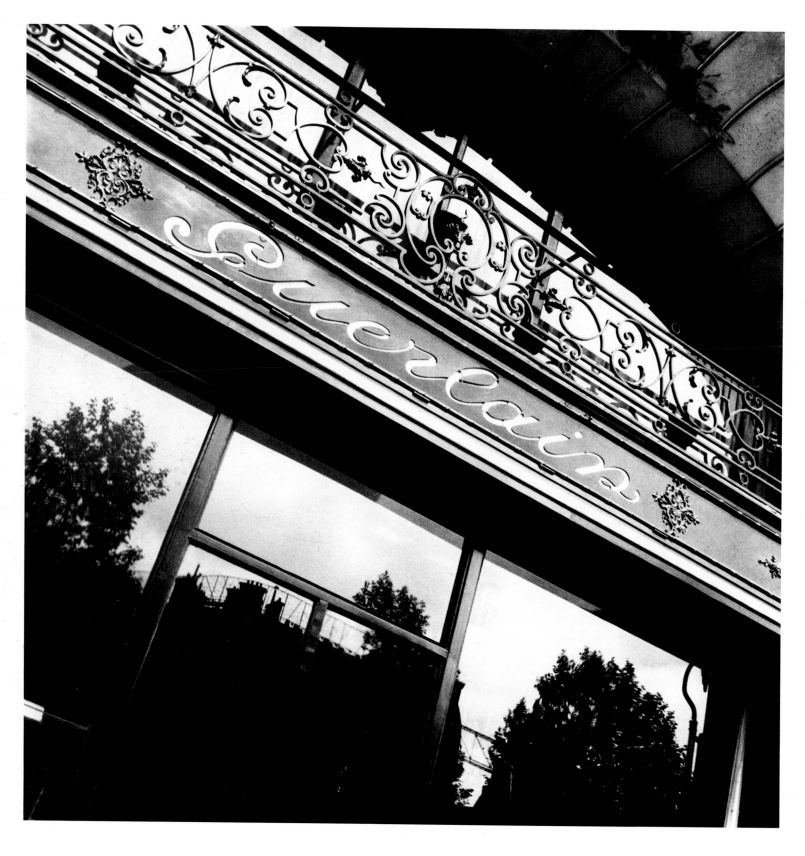

Lee Miller, Guerlain, Paris, c. 1930.
Lee Miller Archives

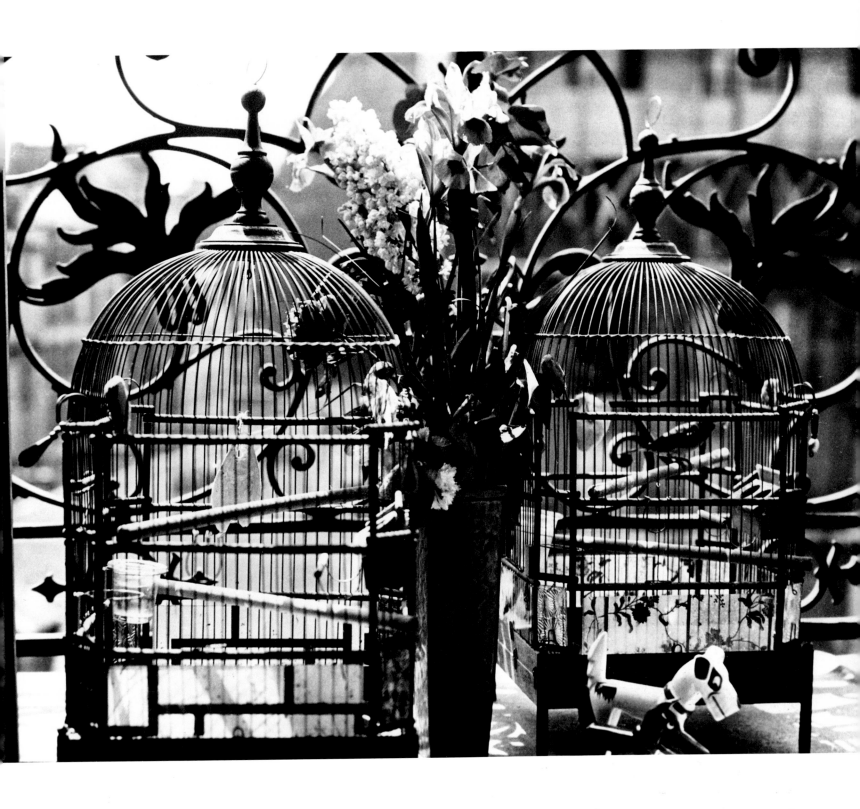

Lee Miller, Caged Birds, Paris, c. 1930.
Lee Miller Archives

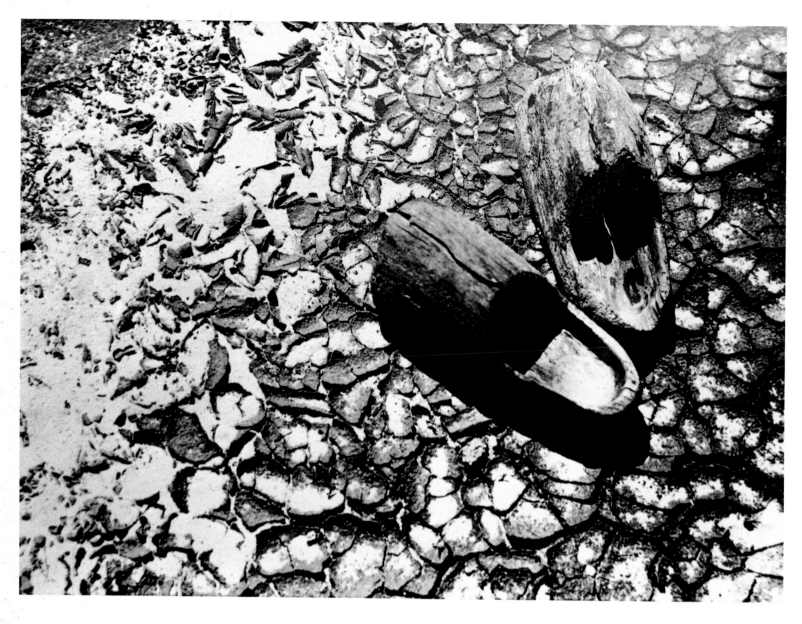

36

Lee Miller, Sabots on Parched Earth,
c. 1930. Lee Miller Archives

Lee Miller, Nude with Wire Mesh Sabre
Guard, c. 1930. Lee Miller Archives

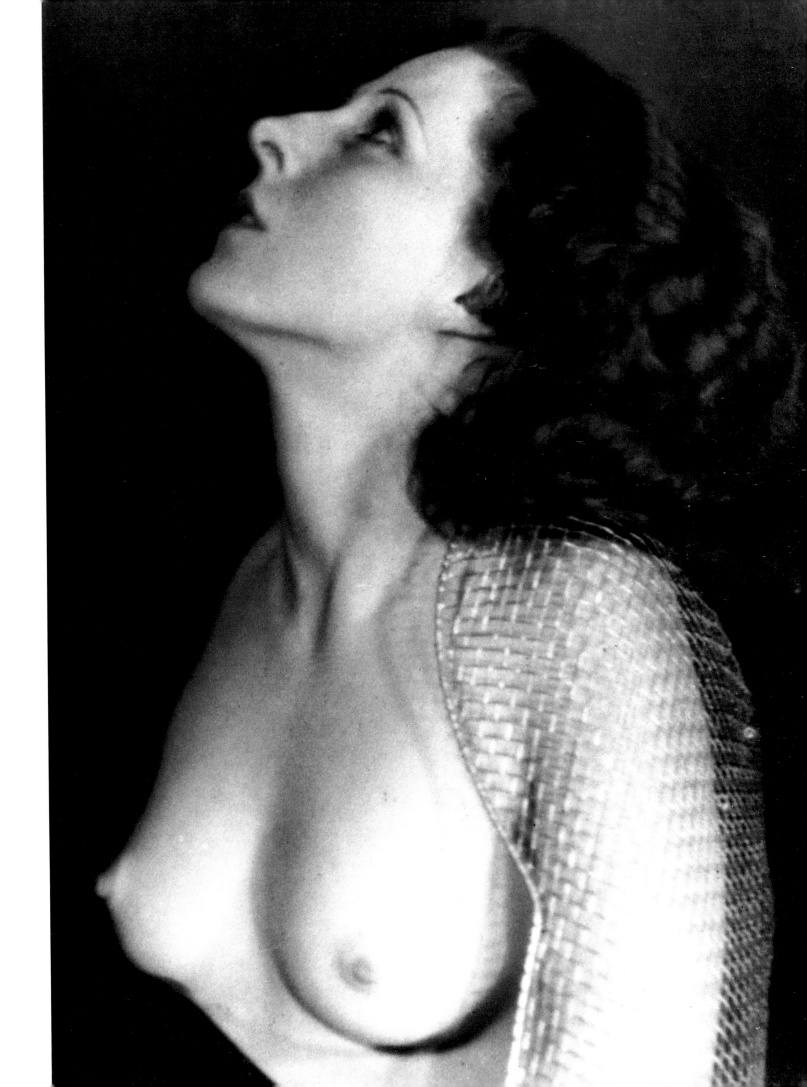

38

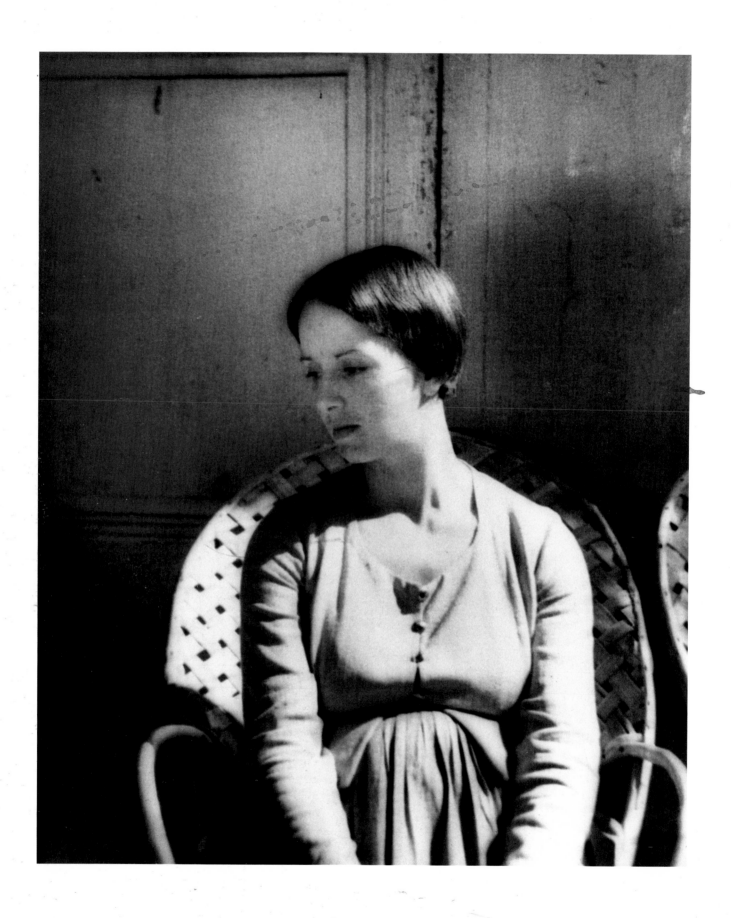

Lee Miller, Inez Duthie, c. 1931.
The Art Institute of Chicago;
The Julien Levy Collection

Lee Miller, Gertrude Lawrence,
New York, 1933. Lee Miller Archives

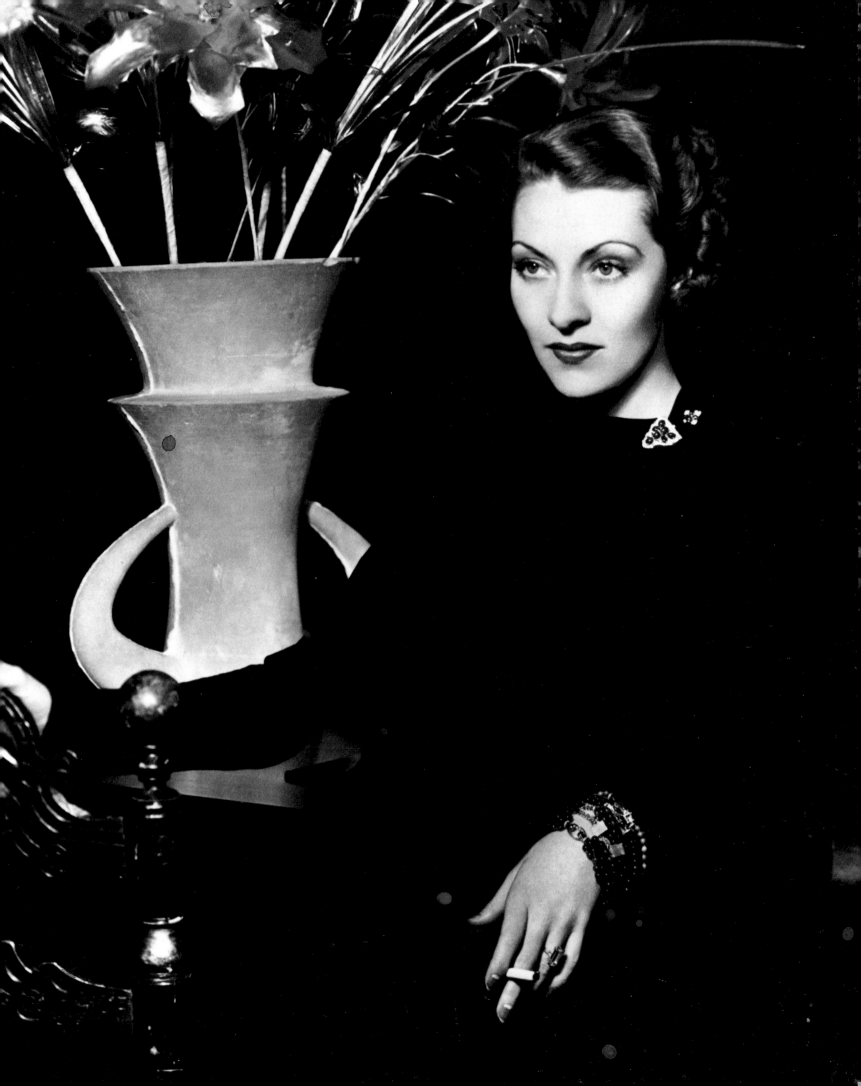

Lee Miller, Joseph Cornell, 1933.
Lee Miller Archives

Lee Miller, Work by Joseph Cornell,
1933. Lee Miller Archives

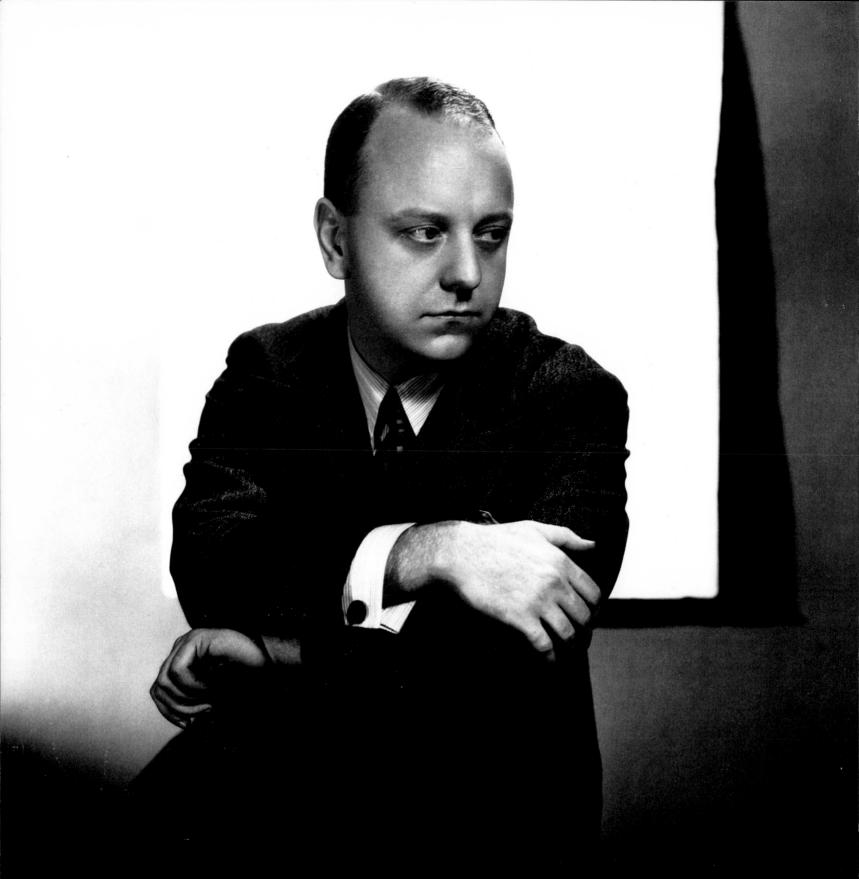

Lee Miller, Virgil Thompson, New York,
1933. Lee Miller Archives

Lee Miller
Eileen Agar at the Brighton Pavillion
England, 1937
Lee Miller Archives

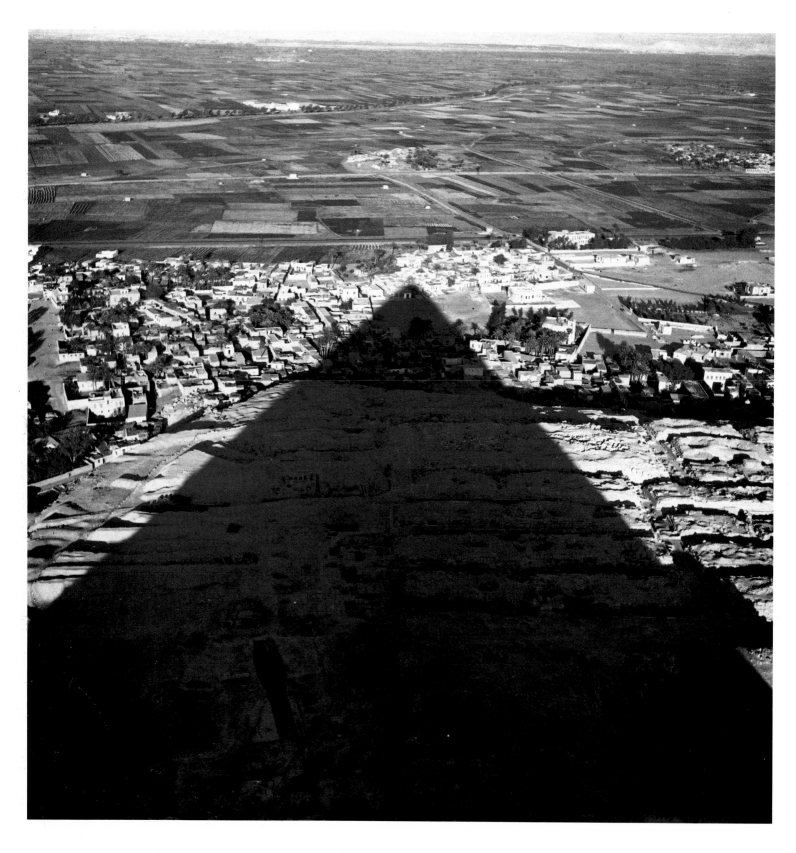

Lee Miller, From the Top of the Great
Pyramid, Egypt, c. 1938. Lee Miller Archives

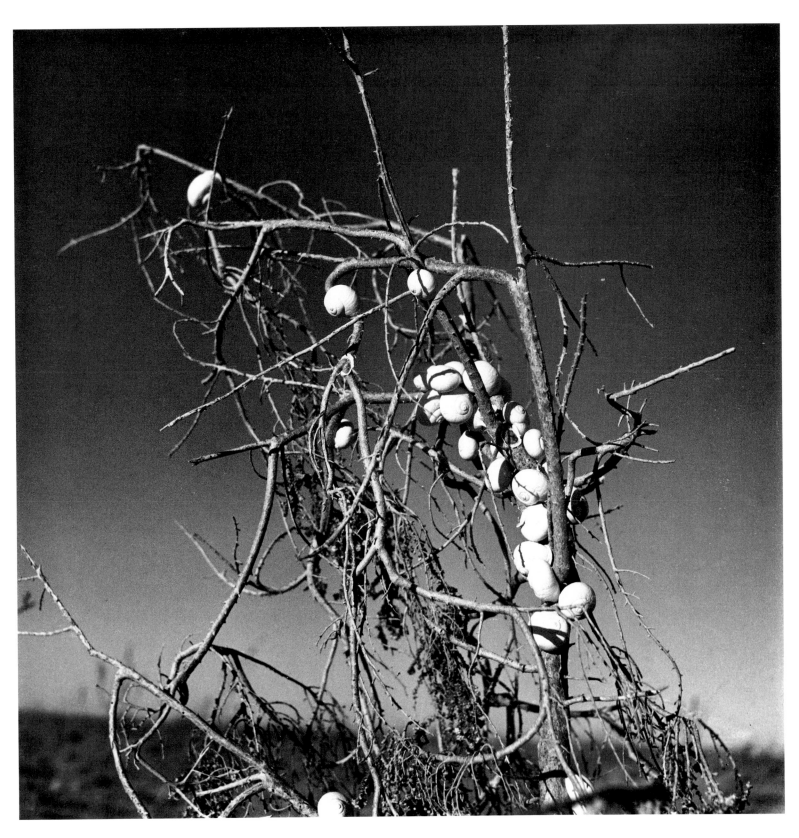

Lee Miller, Bleached Shells of Snails
Marooned by the Receding Waters of the
Nile, Egypt, c. 1936. Lee Miller Archives

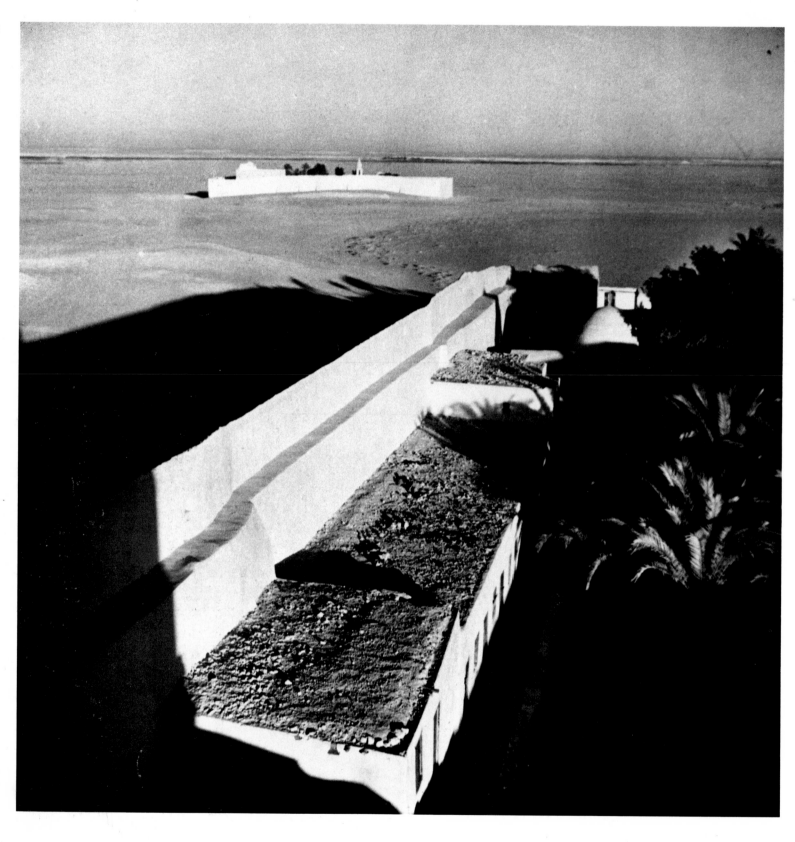

Lee Miller, The Monasteries of Dier
Simon and Dier Barnabas, Egypt,
c. 1936. Lee Miller Archives

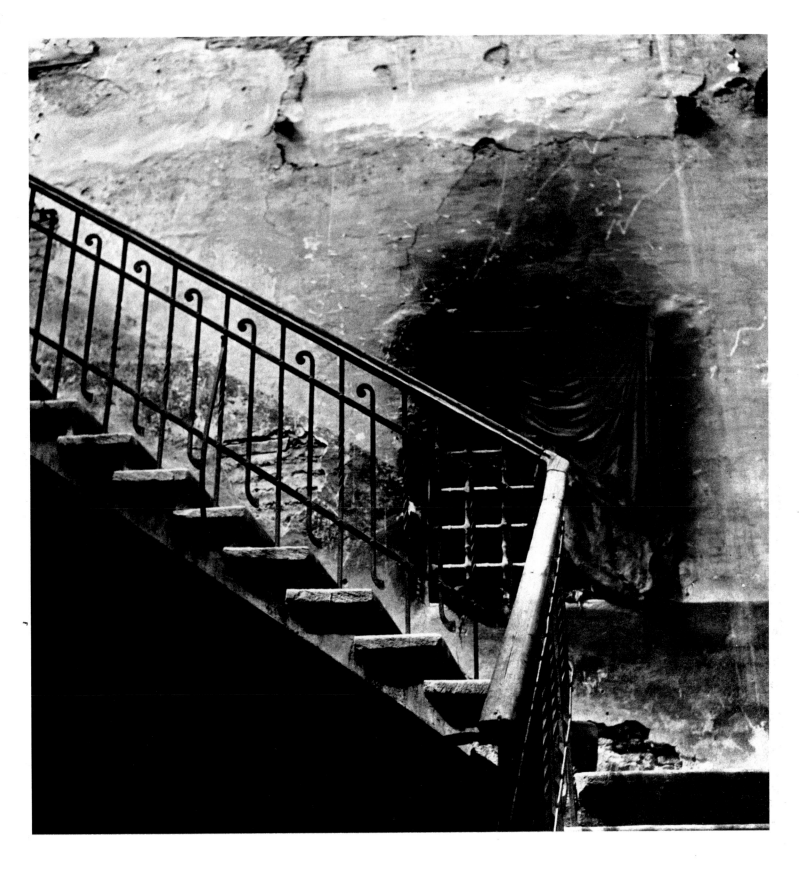

Lee Miller, Stairway, Cairo, 1936.
Lee Miller Archives

48

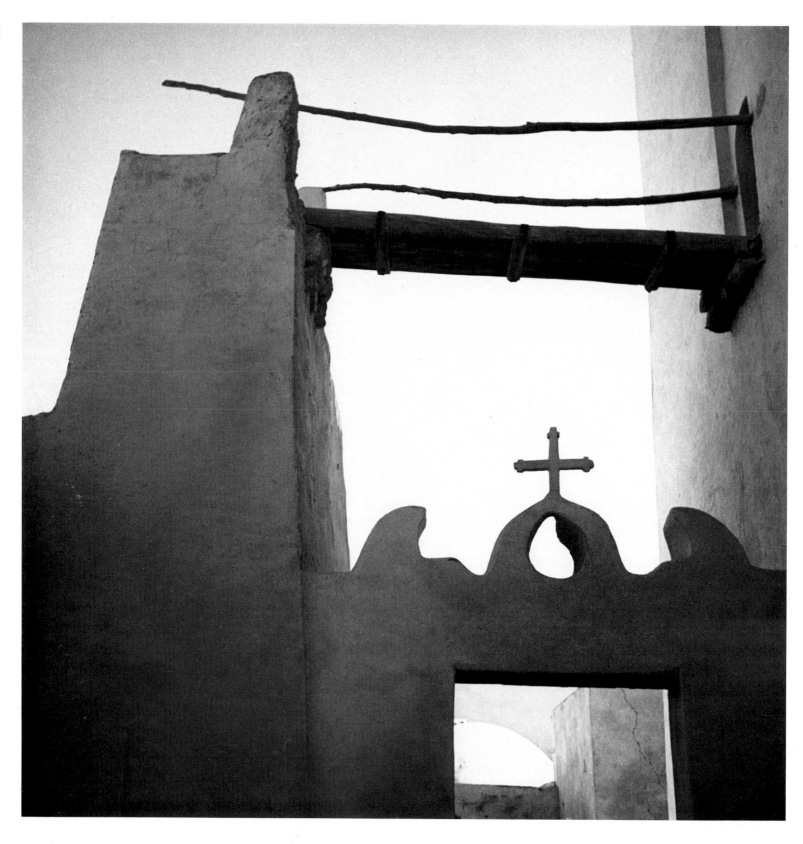

Lee Miller, Egypt, c. 1936.
Lee Miller Archives

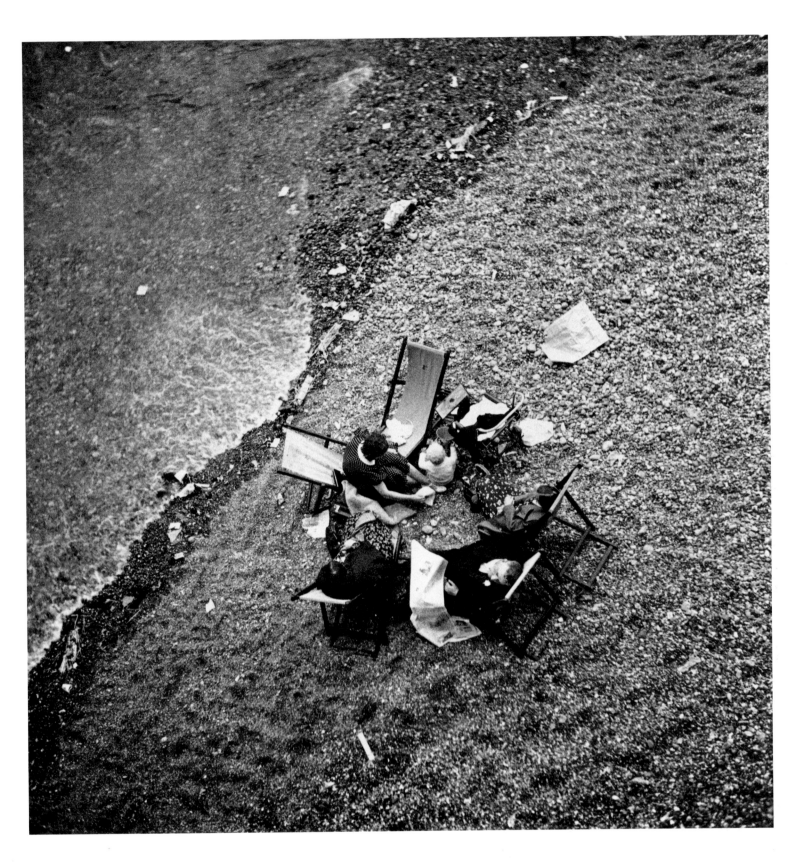

Lee Miller, Brighton Beach, England,
1937. Lee Miller Archives

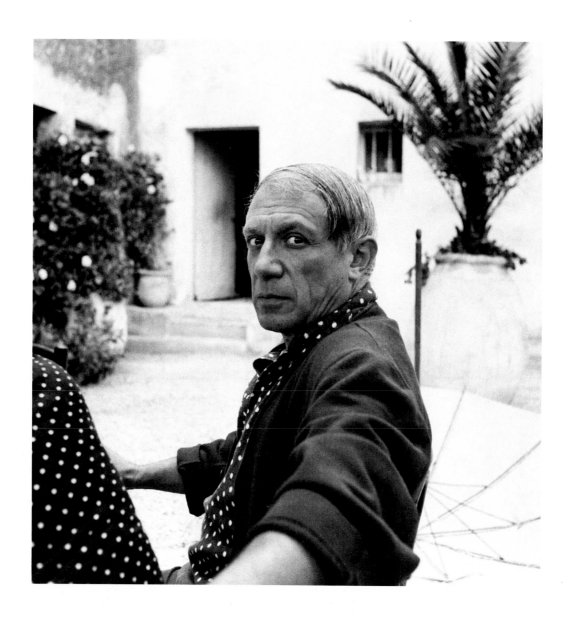

Lee Miller, Picasso, Hôtel Vaste Horizon,
Mougins, France, 1937. Lee Miller Archives

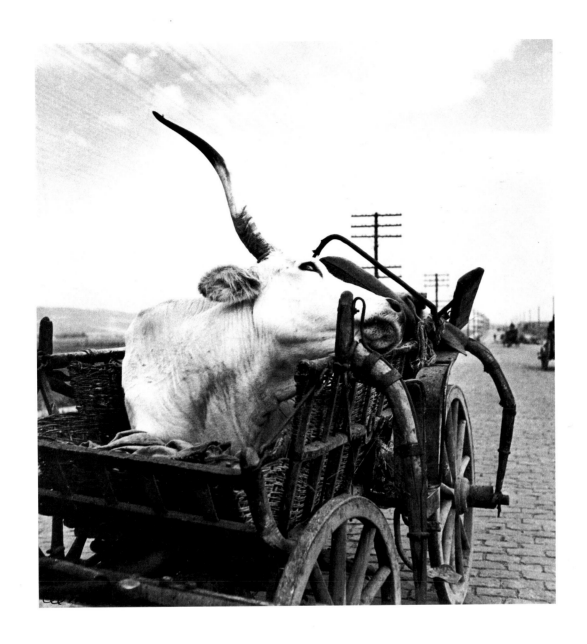

Lee Miller
On the Road
Romania, 1938
Lee Miller Archives

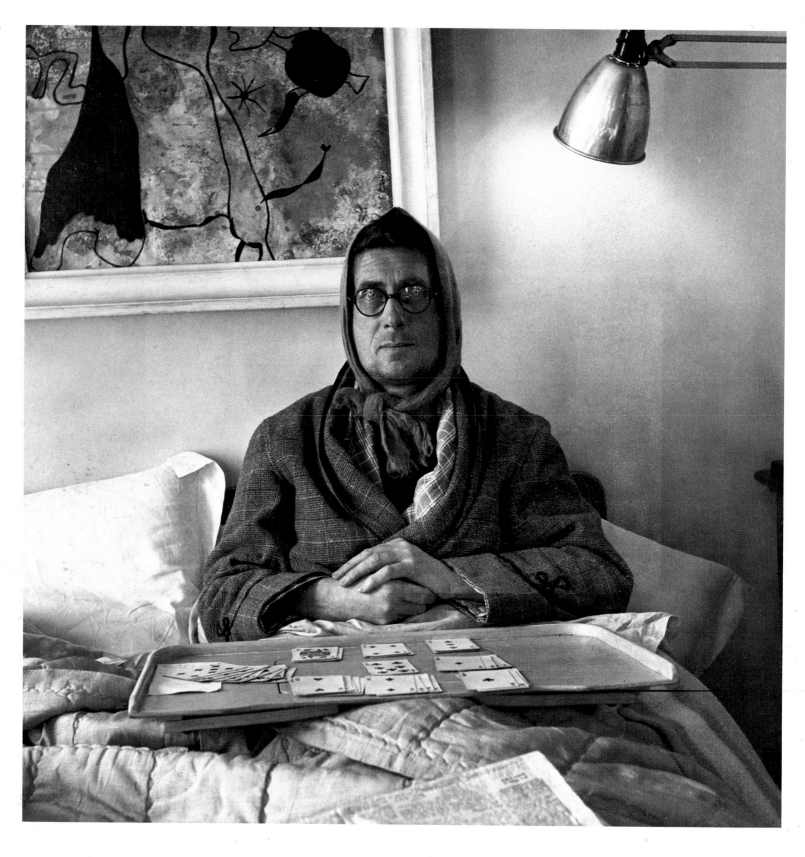

Lee Miller, Roland Penrose with Mumps,
London, 1941. Lee Miller Archives

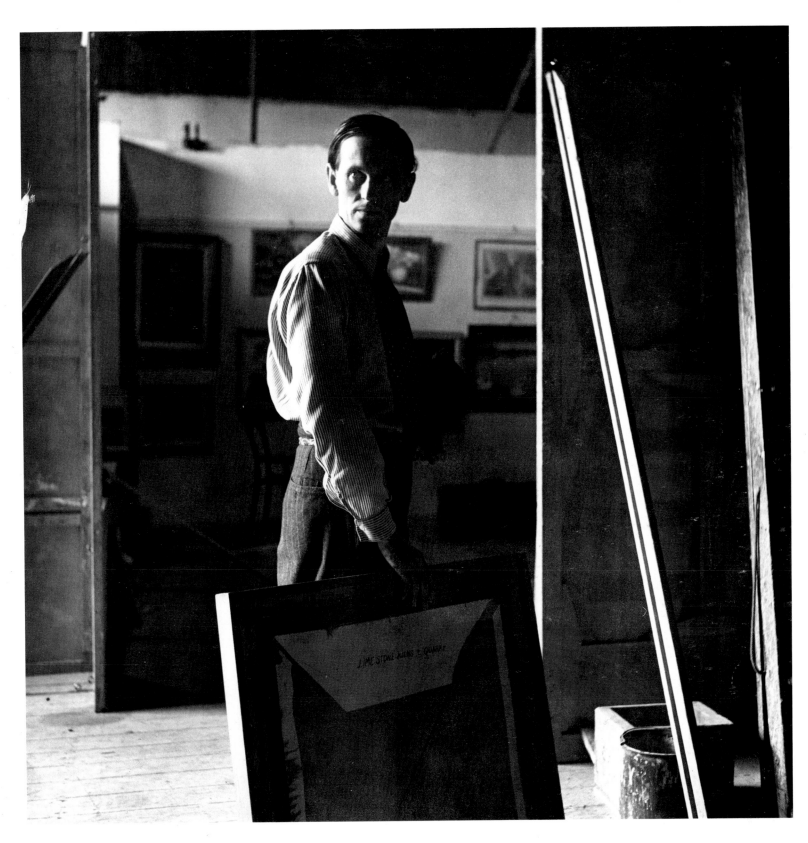

Lee Miller, Graham Sutherland,
England, 1940. Lee Miller Archives

Lee Miller, Roof of University College,
London, from *Grim Glory*, 1940.
Lee Miller Archives

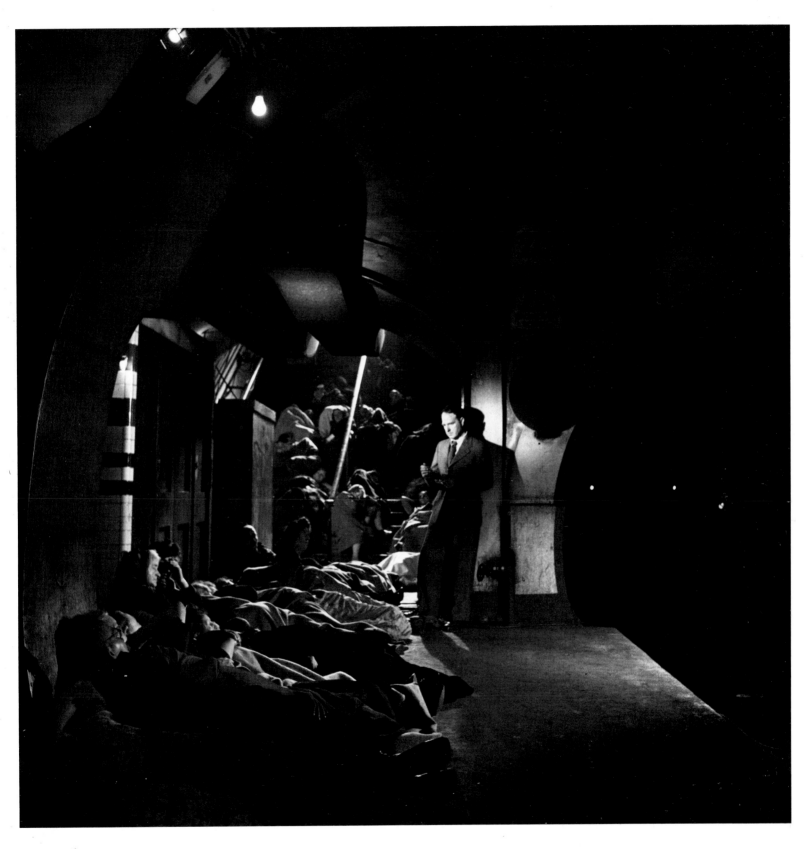

Lee Miller, Henry Moore Making
Sketches, Holborn Underground Station,
London, 1940.
Lee Miller Archives

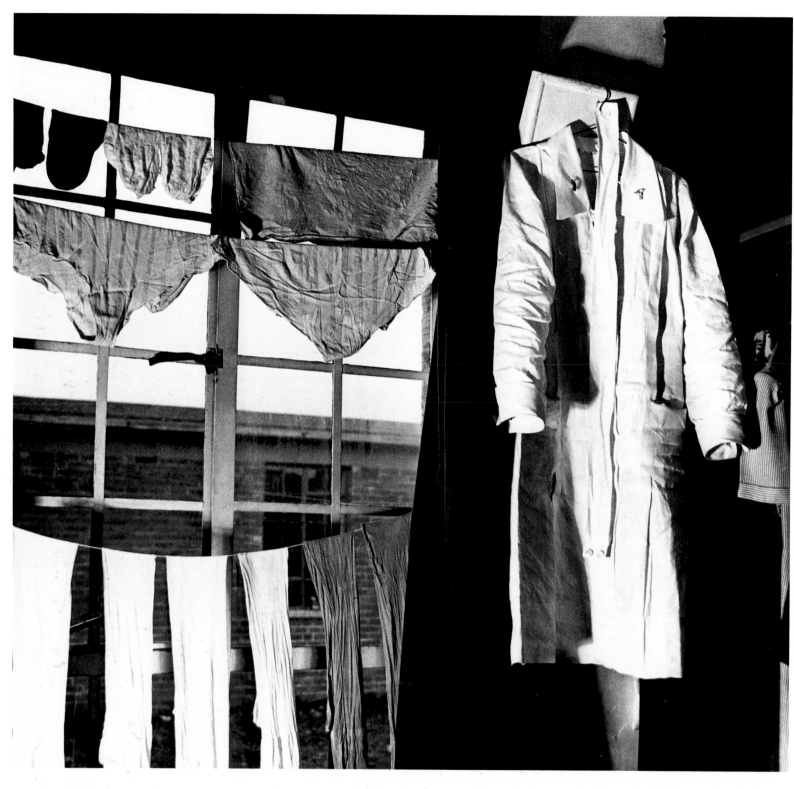

Lee Miller, WRVS Billet, England, from
Grim Glory, c. 1941. Lee Miller Archives

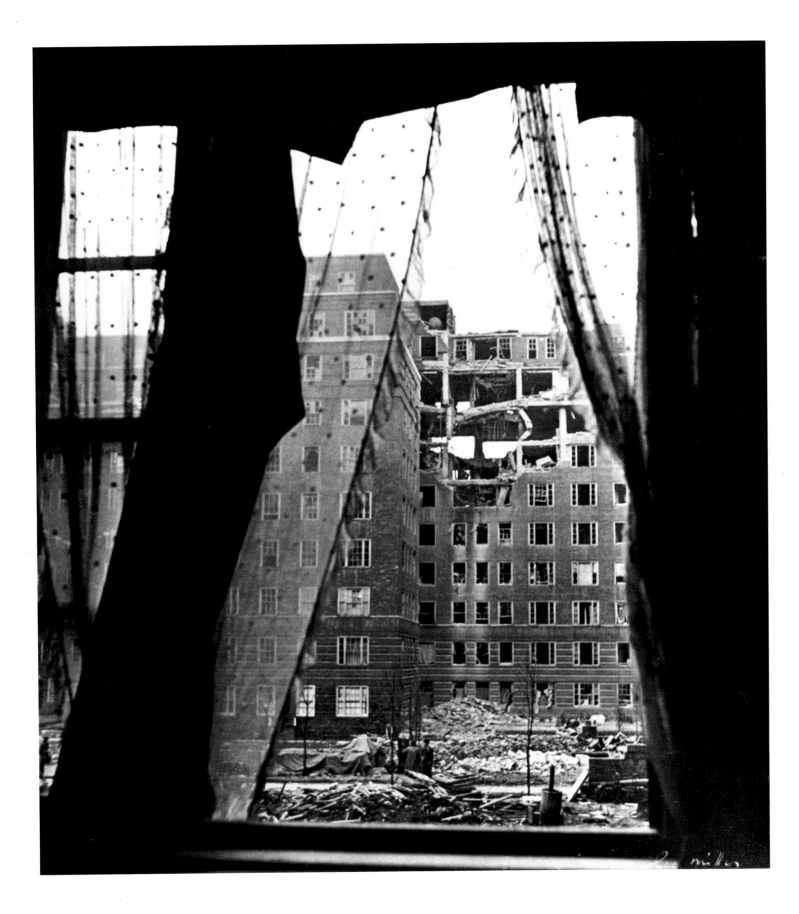

Lee Miller, Dolphin Court, London during
the Blitz, from *Grim Glory*, 1940.
Lee Miller Archives

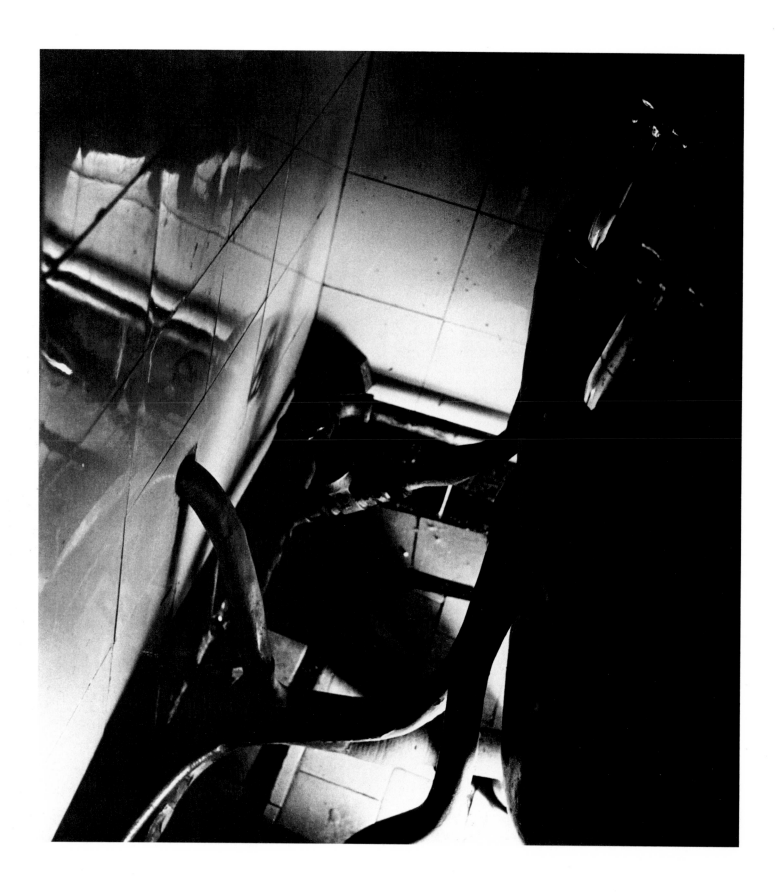

Lee Miller, English Plumbing at its Most
Fascinating, from *Grim Glory*, c. 1940.
Lee Miller Archives

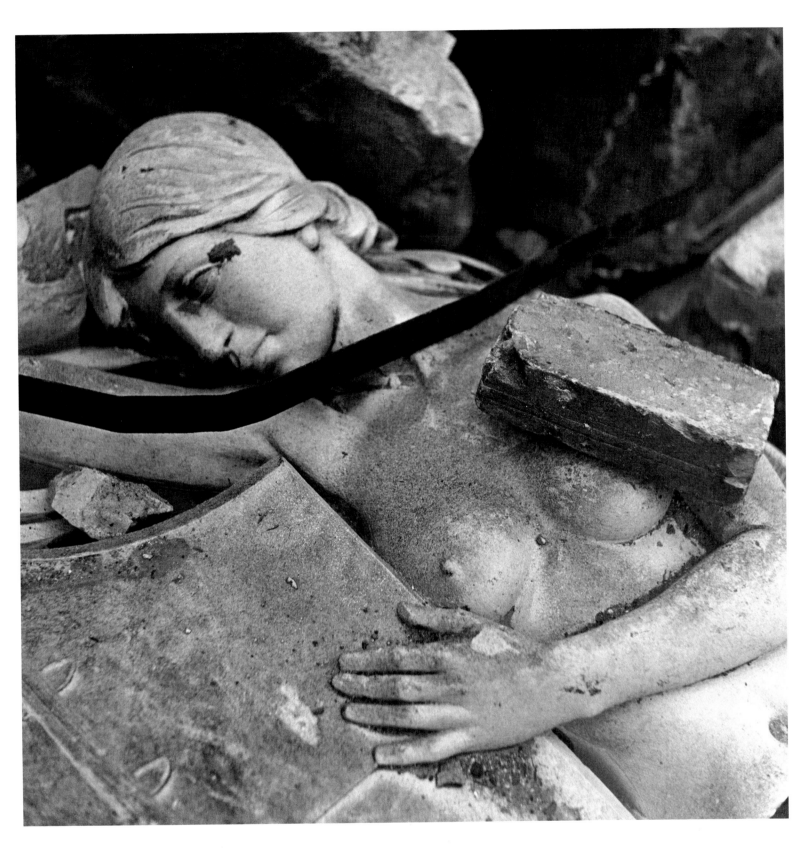

Lee Miller, Revenge on Culture, from
Grim Glory, 1940. Lee Miller Archives

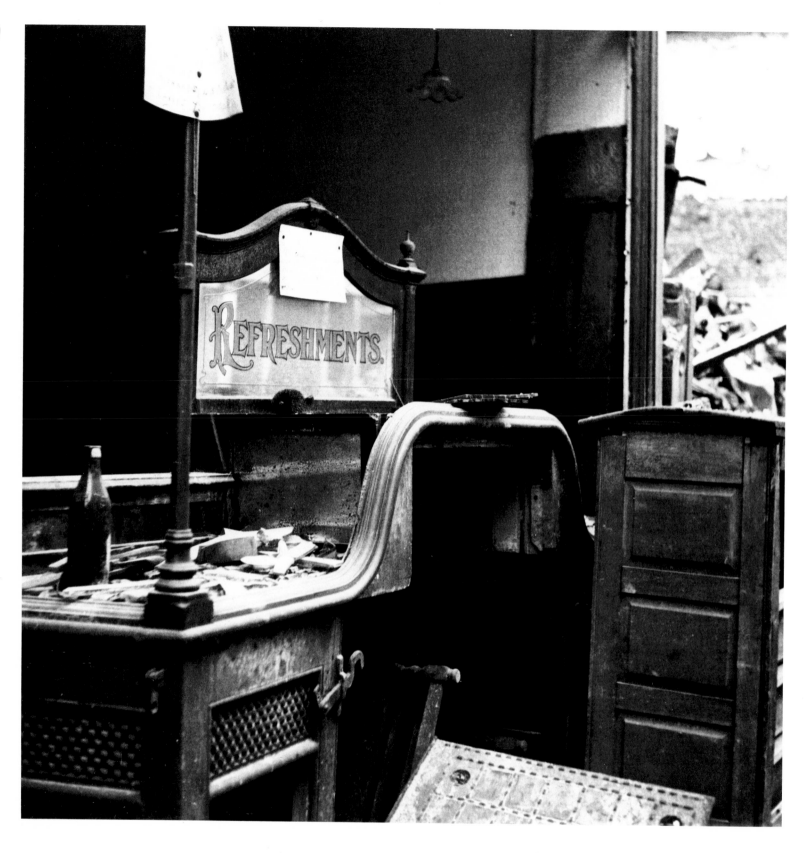

Lee Miller, A London Cafe Wrecked in
the Blitz, from *Grim Glory*, 1940.
Lee Miller Archives

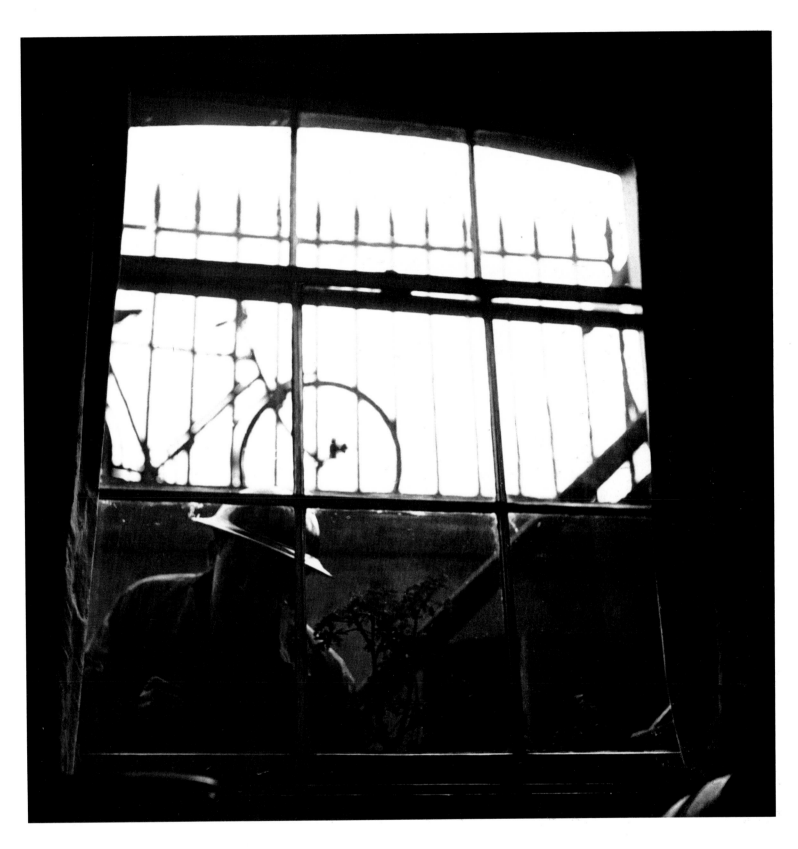

Lee Miller, The Well Known Art Dealer
Freddie Mayor doing his rounds as an Air
Raid Warden, London, 1940. Lee Miller Archives

62

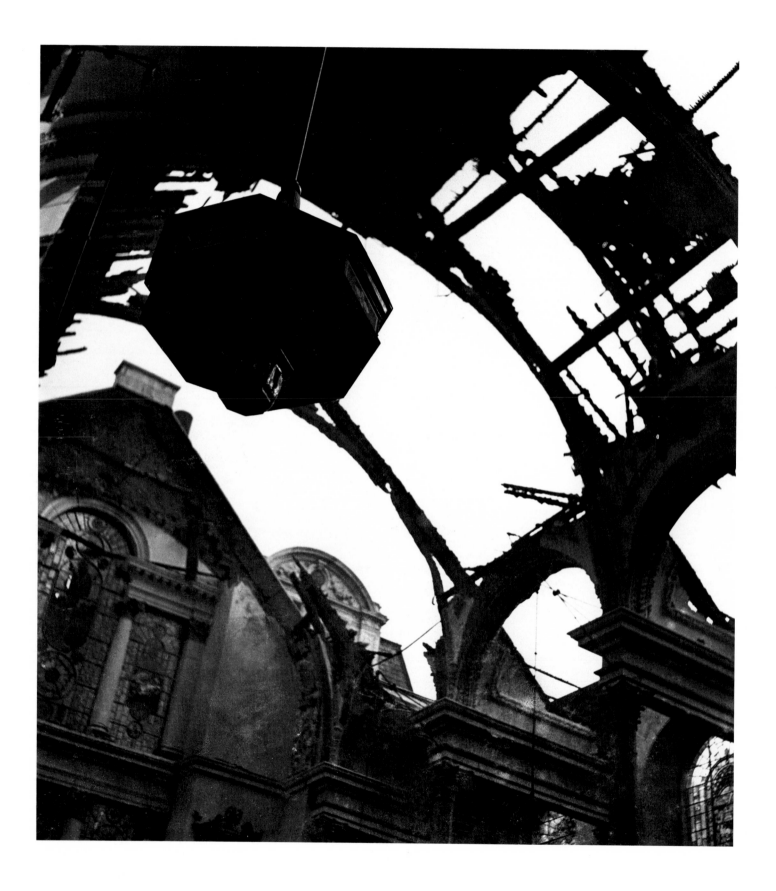

Lee Miller, The Roof of St. James's
Piccadilly, Destroyed in the Blitz, from
Grim Glory, 1940. Lee Miller Archives

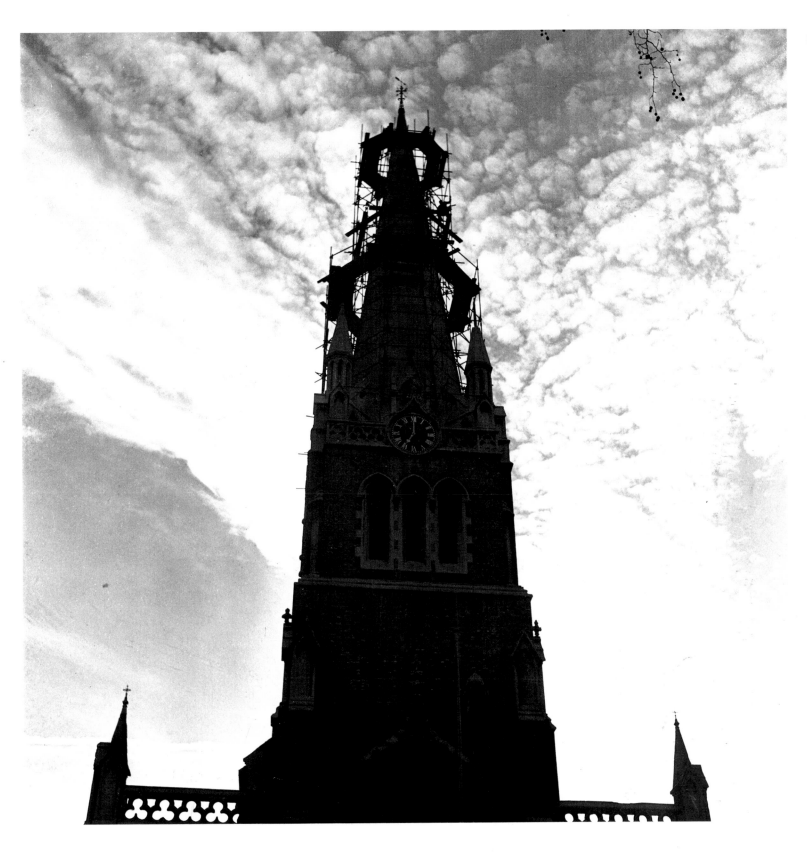

Lee Miller, Paddington, London, from
Grim Glory, 1940. Lee Miller Archives

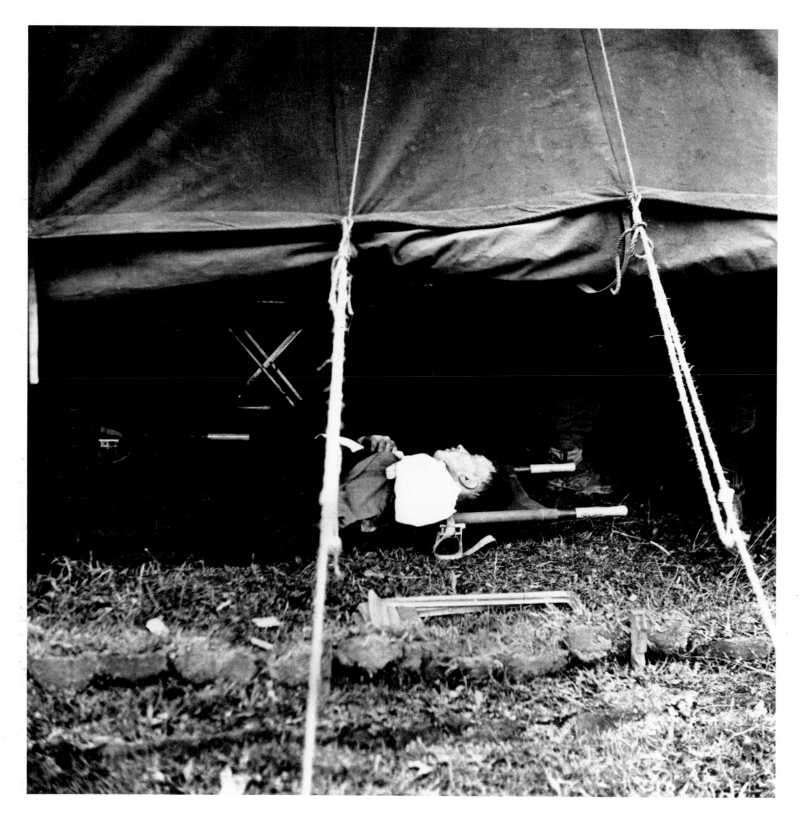

Lee Miller, Casualty Awaiting Evacuation
from a Normandy Field Hospital, France,
1944. Lee Miller Archives

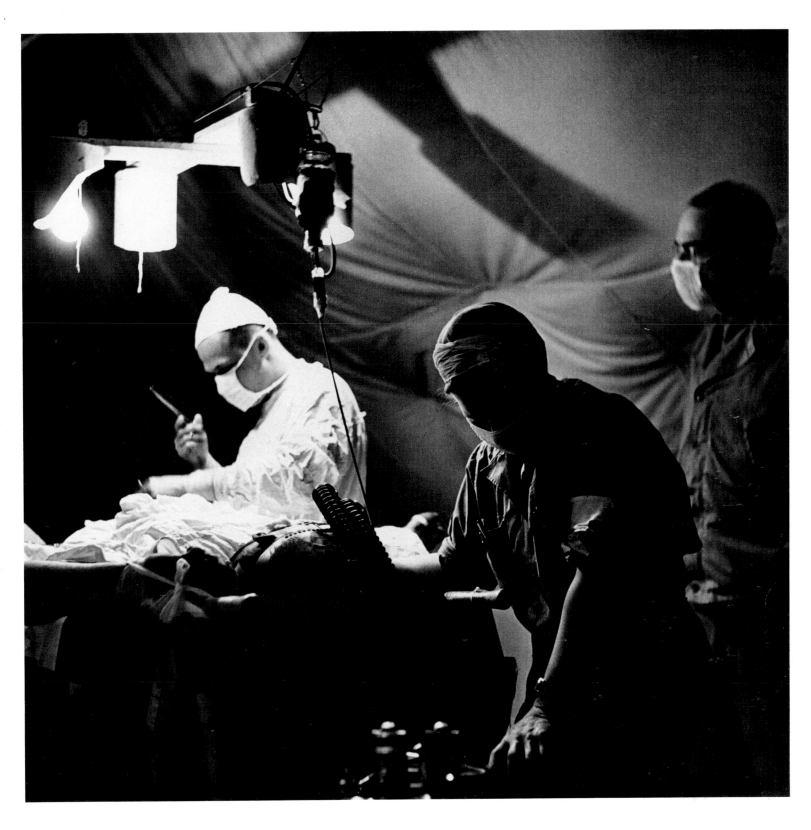

Lee Miller, Normandy Field Hospital,
France, 1944. Lee Miller Archives

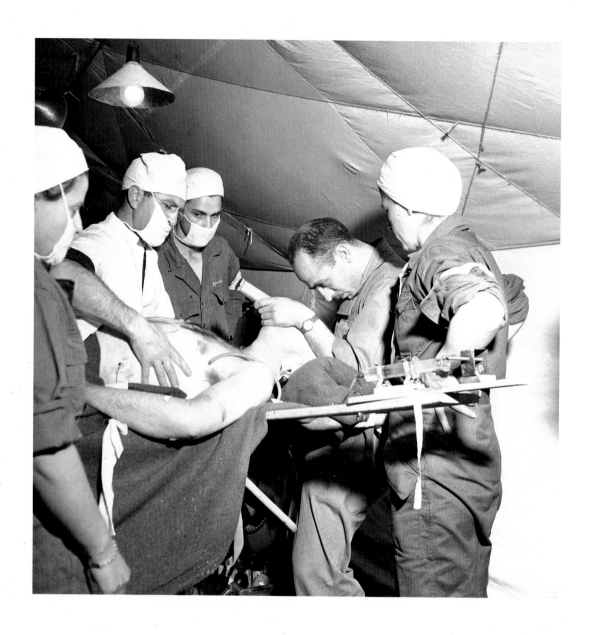

Lee Miller
Emergency Resuscitation in
a Normandy Field Hospital
France, 1944
Lee Miller Archives

Lee Miller, U.S. Bombs Exploding on the
Fortress of St. Mâlo, France, 1944.
Lee Miller Archives

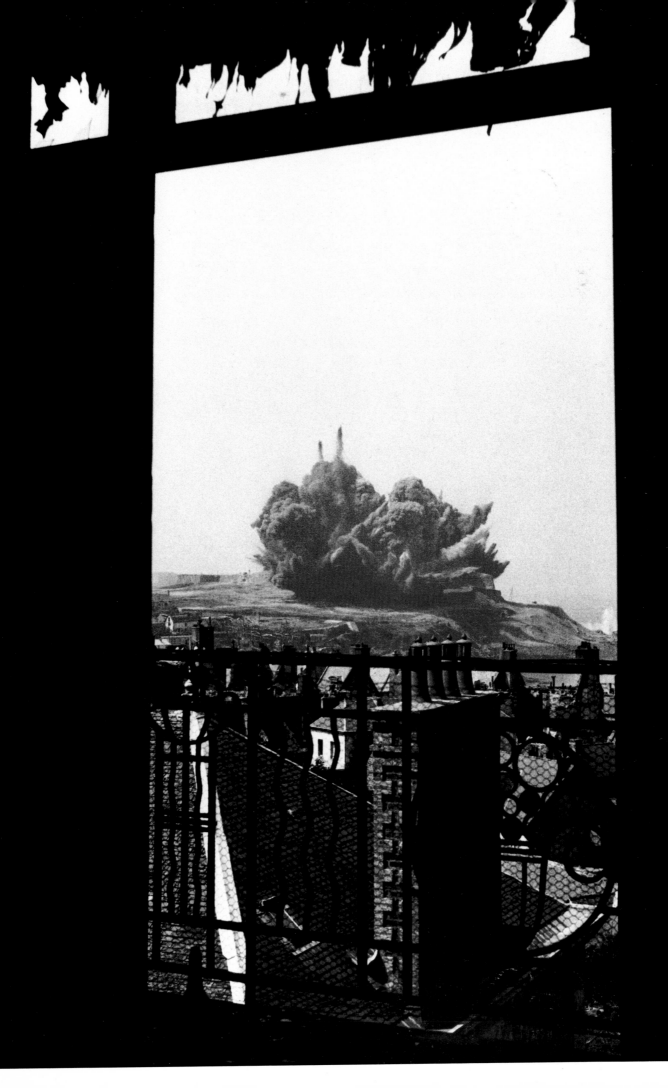

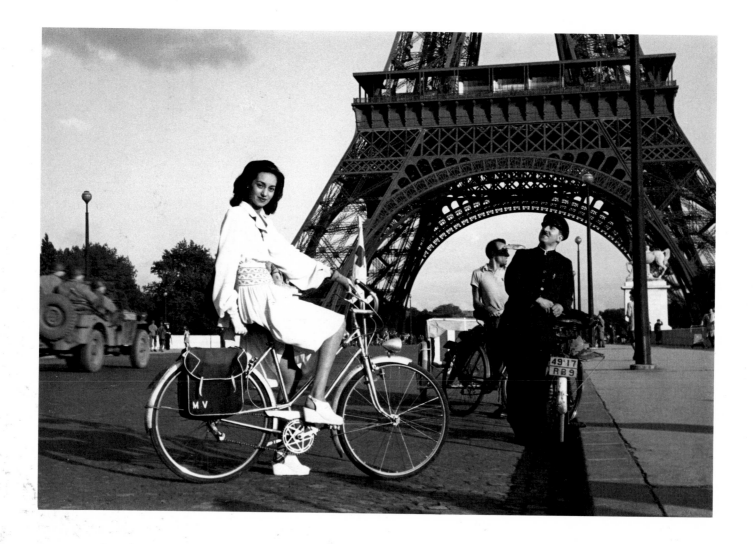

Lee Miller, Paris Fashion, 1944.
Lee Miller Archives

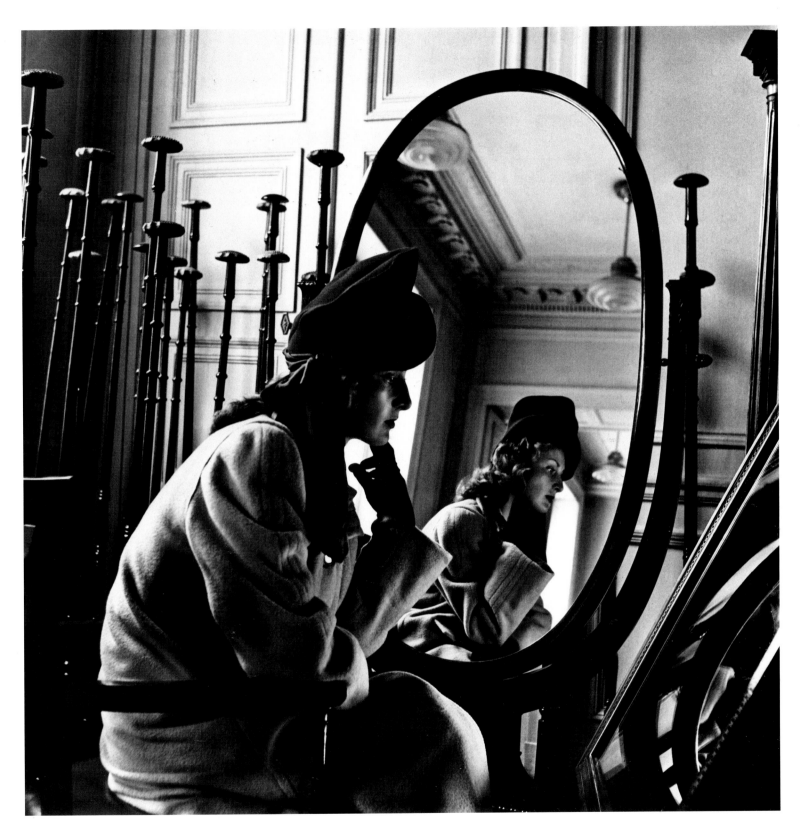

Lee Miller, Model Preparing for a
Millinery Salon after the Liberation of
Paris, 1944. Lee Miller Archives

Lee Miller, Paris under Snow, 1945.
Lee Miller Archives

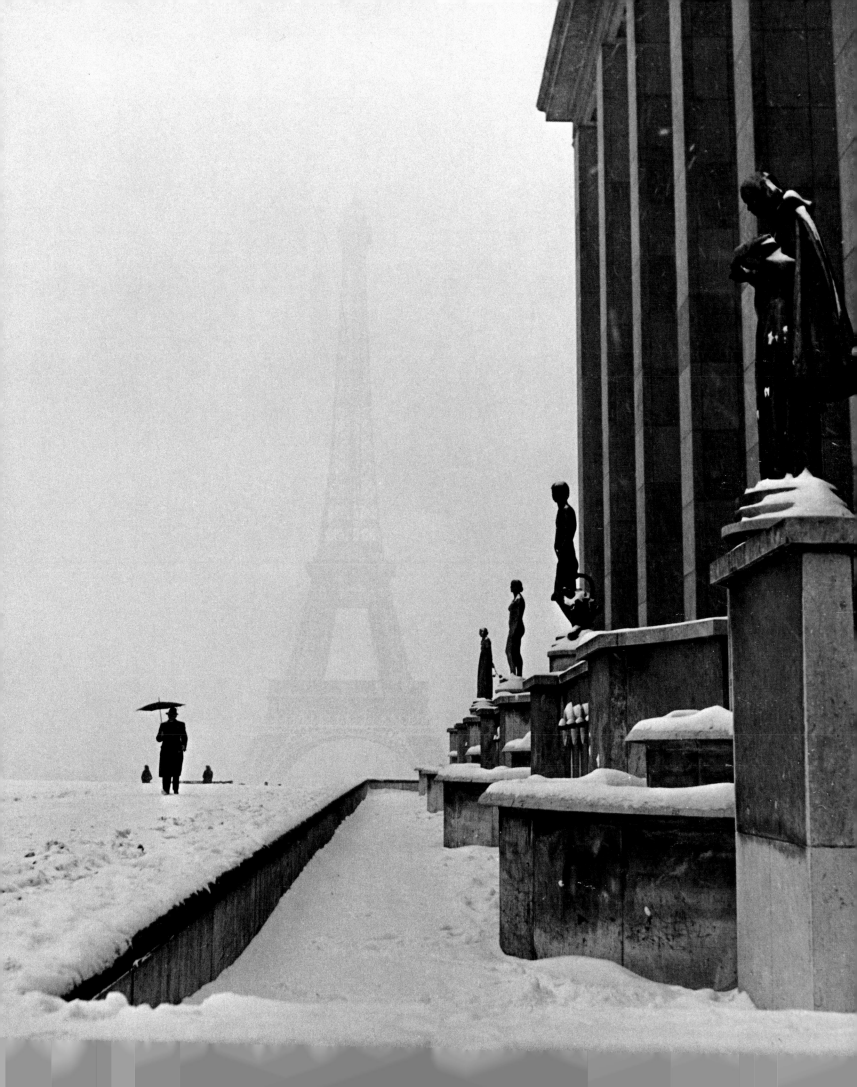

72

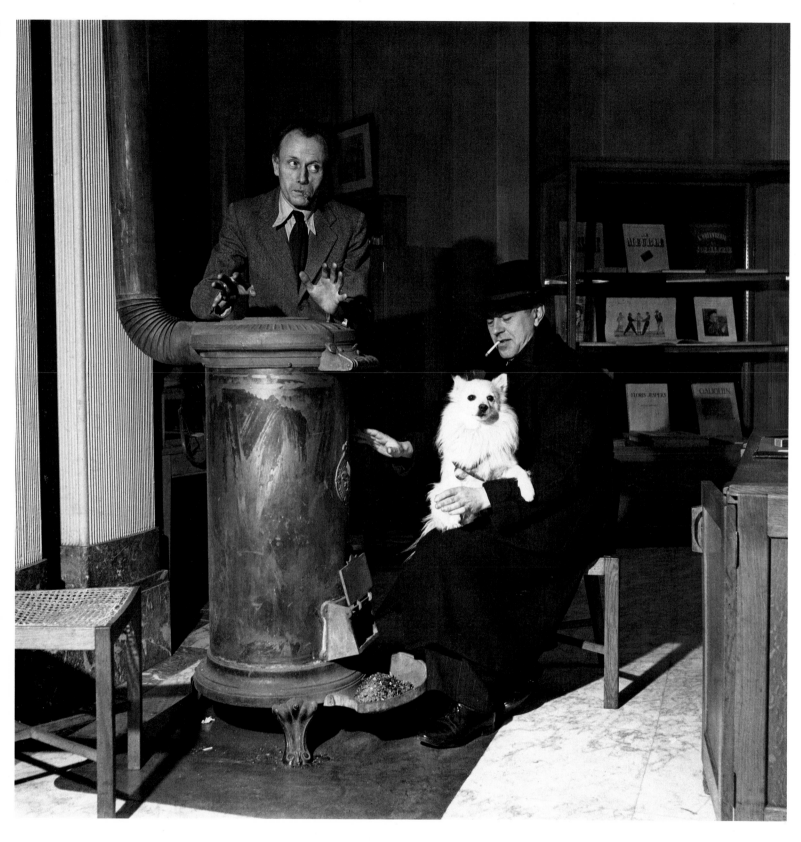

Lee Miller, Paul Delvaux and René
Magritte, Brussels, 1944.
Lee Miller Archives

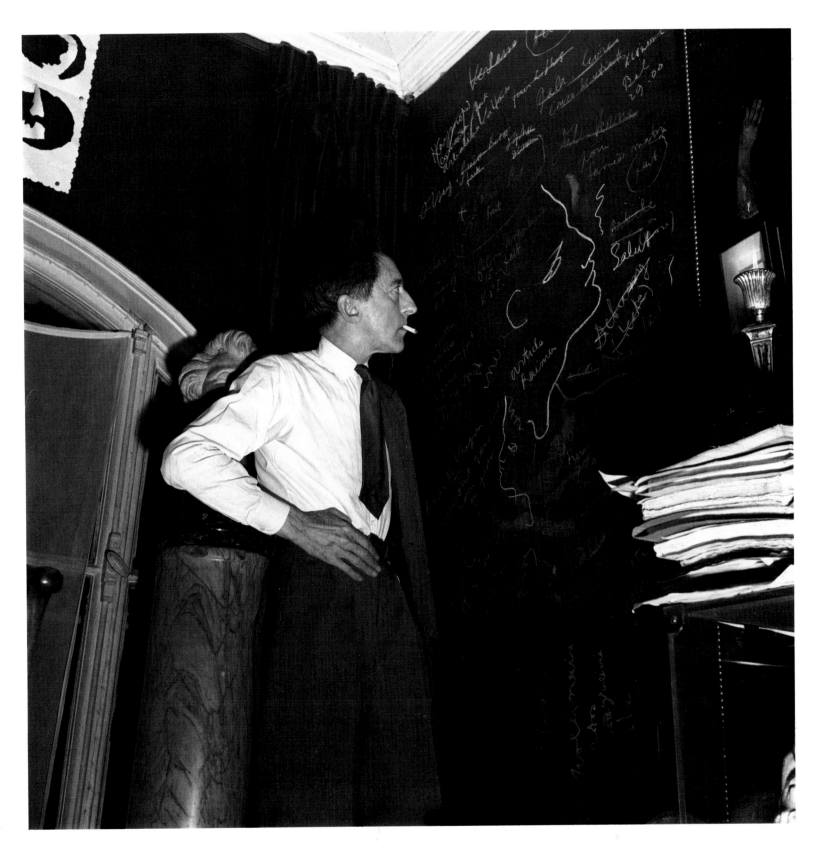

Lee Miller, Jean Cocteau, 1944.
Lee Miller Archives

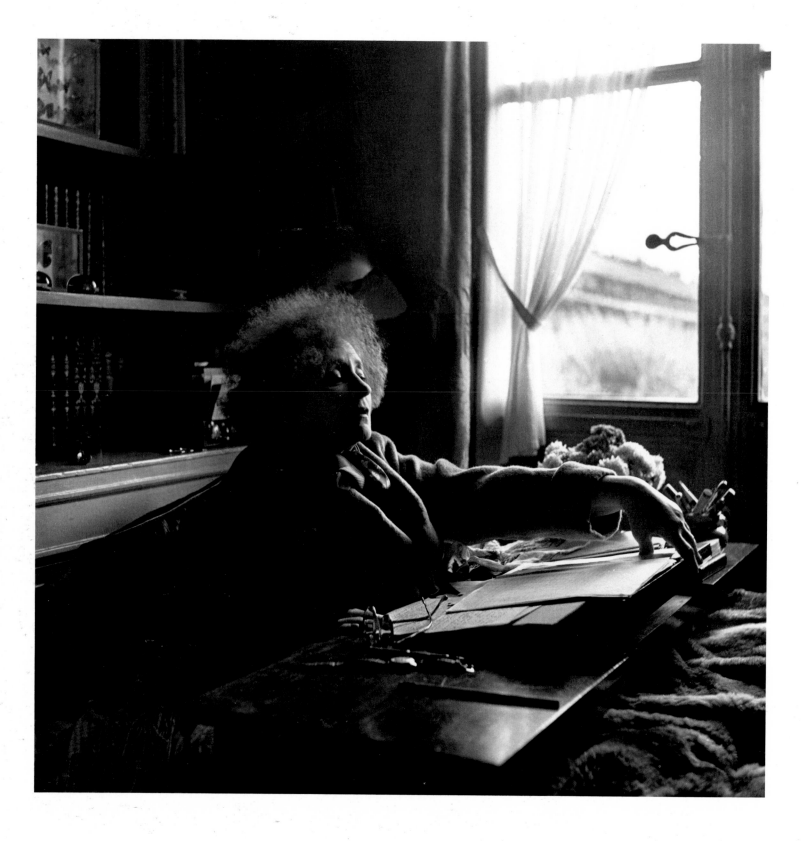

Lee Miller, Colette, Age 71, in her
Apartment at 9 Rue de Beaujolais,
Paris, 1944. Lee Miller Archives

Lee Miller, Marlene Dietrich in Paris
with the U.S.O. to Entertain the Troops,
1944. Lee Miller Archives

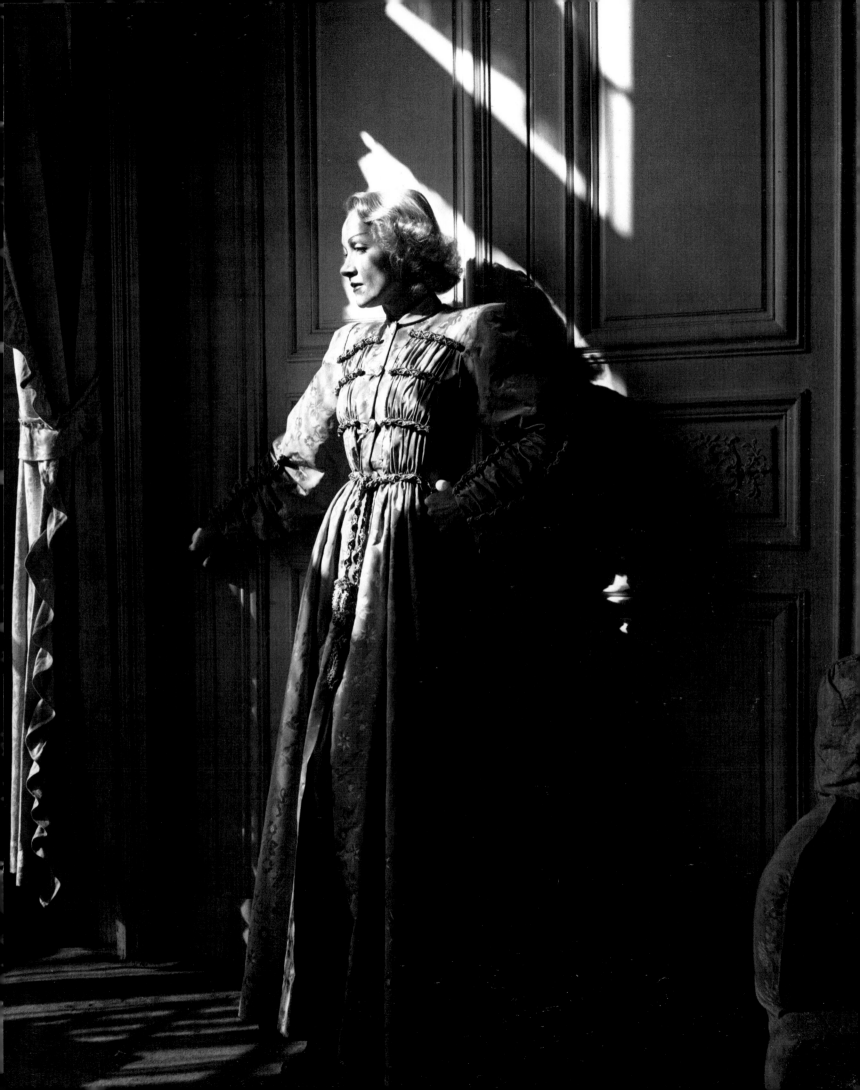

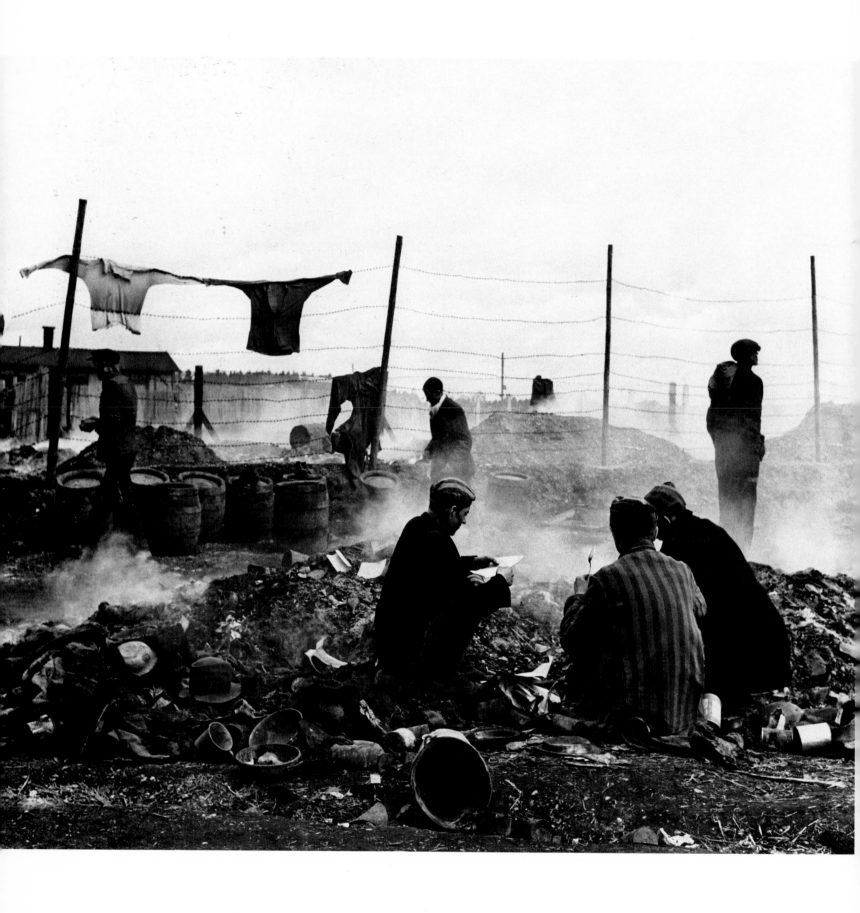

Lee Miller, Freed Dachau Prisoners
Scavenging in the Rubbish Dump, 1945.
Lee Miller Archives

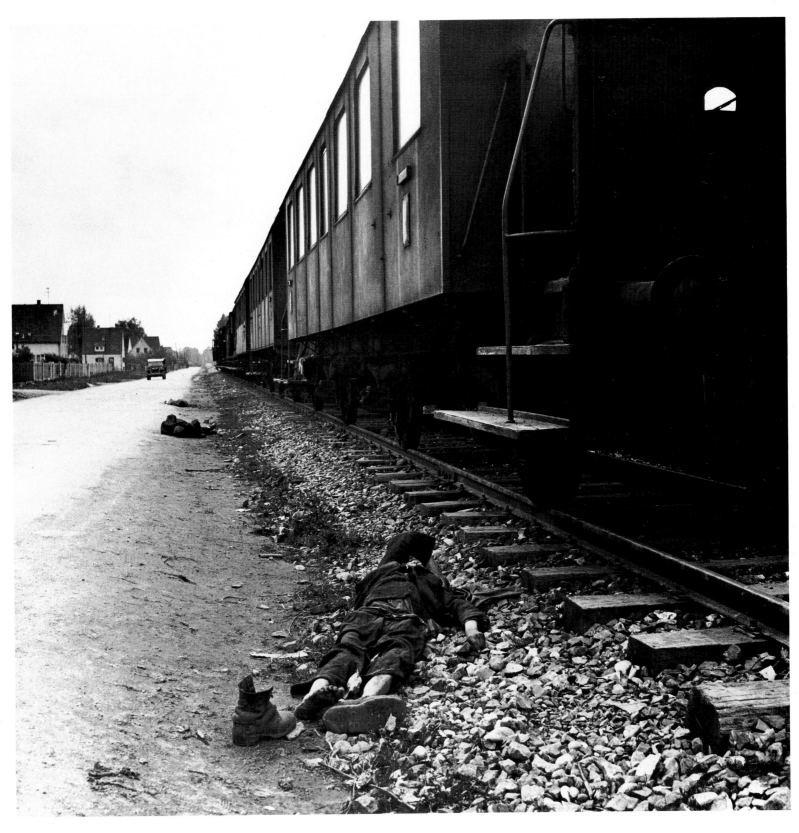

Lee Miller, Trains at Dachau: Prisoners
have died on the short march to camp,
1945. Lee Miller Archives

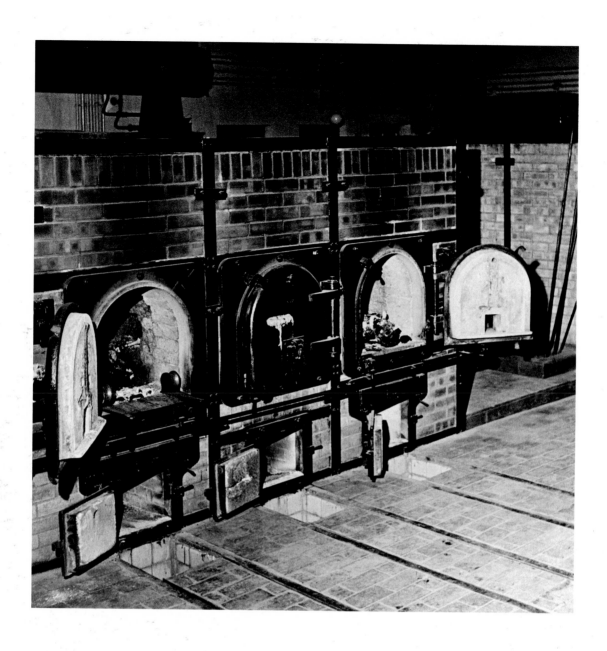

Lee Miller
Cremation Ovens
Buchenwald, Germany, 1945
Lee Miller Archives

Lee Miller, Buchenwald, Germany:
Guards Beaten by Liberated Prisoners
["They threw themselves on the floor for
mercy every time the door opened."
(L.M.)], April 1945.
Lee Miller Archives

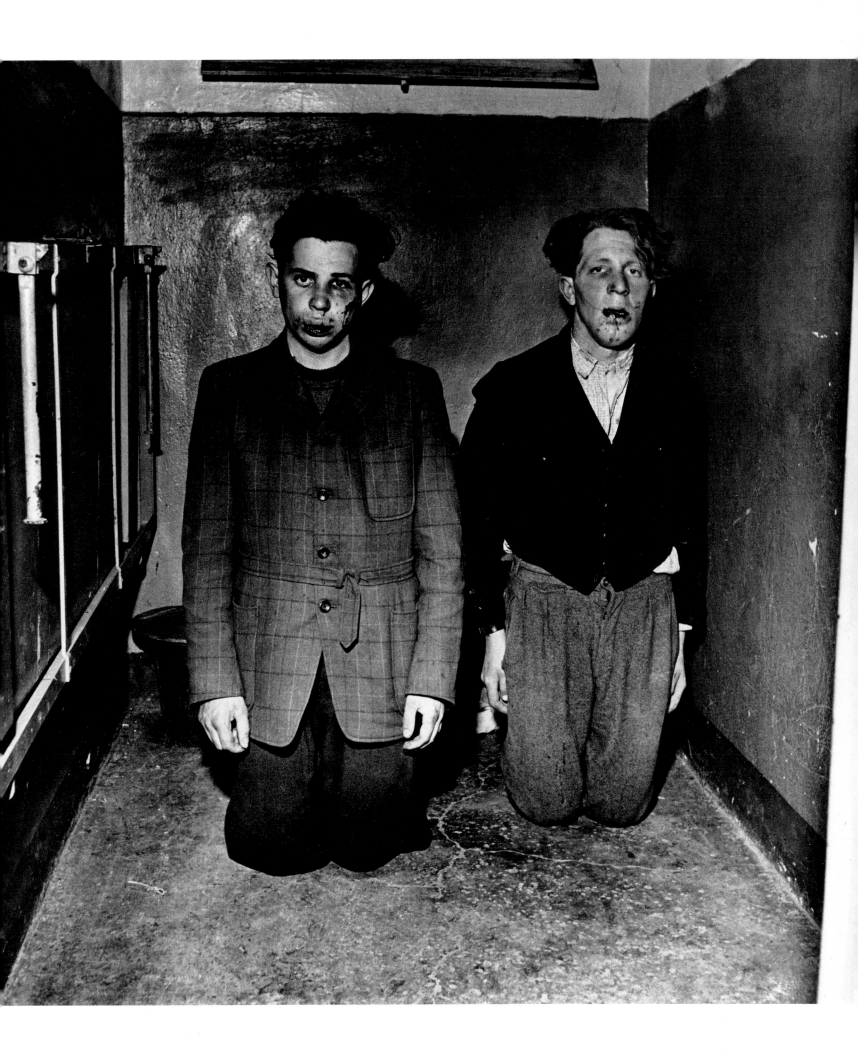

80

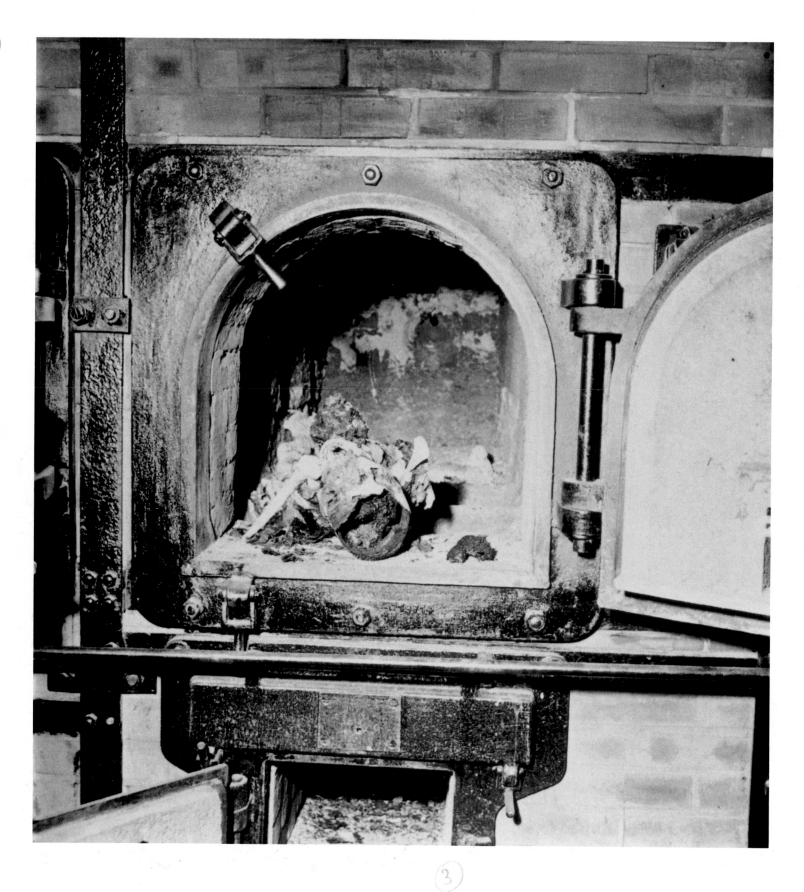

Lee Miller, Dachau, Germany: Human
Remains in a Cremation Furnace, 1945.
Lee Miller Archives

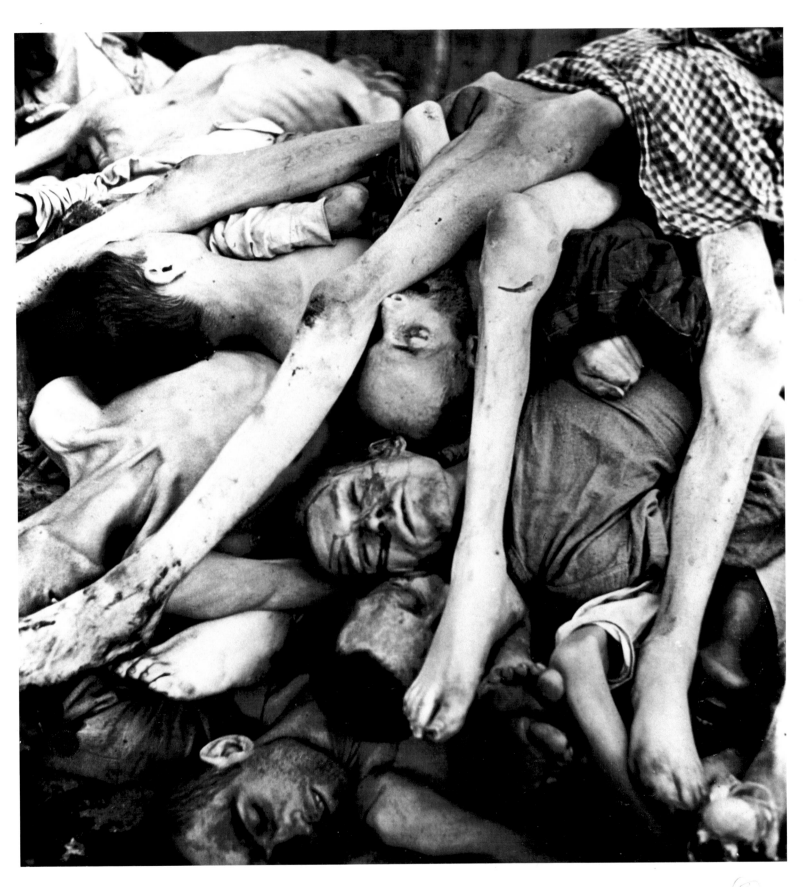

Lee Miller, Dachau, Germany: Dead
Prisoners, April 30, 1945.
Lee Miller Archives

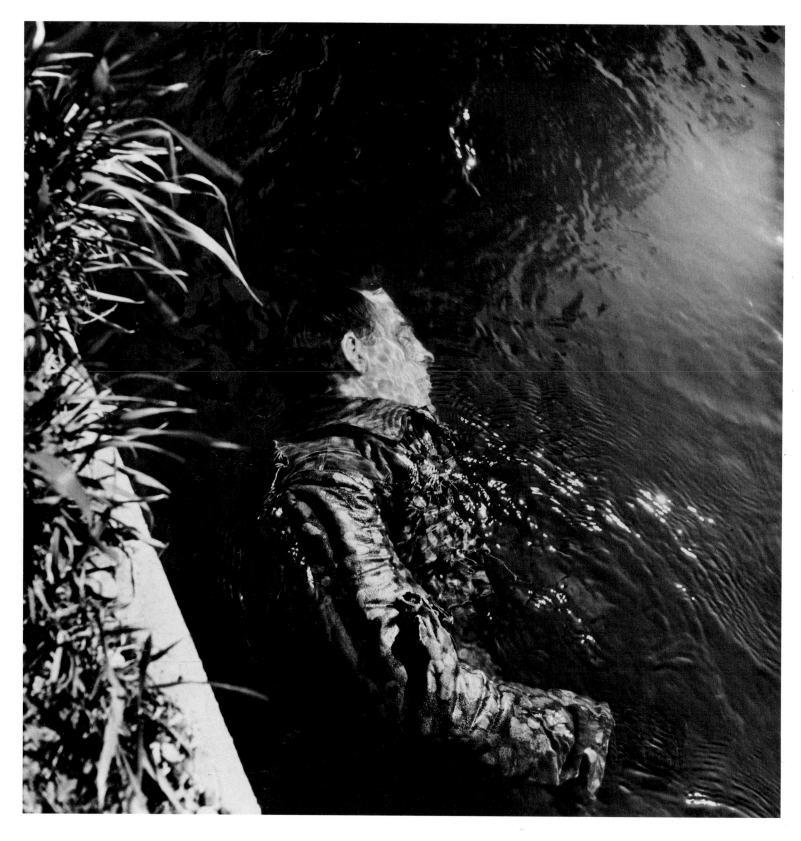

Lee Miller, Dachau, Germany: Murdered
Prison Guard, 1945. Lee Miller Archives

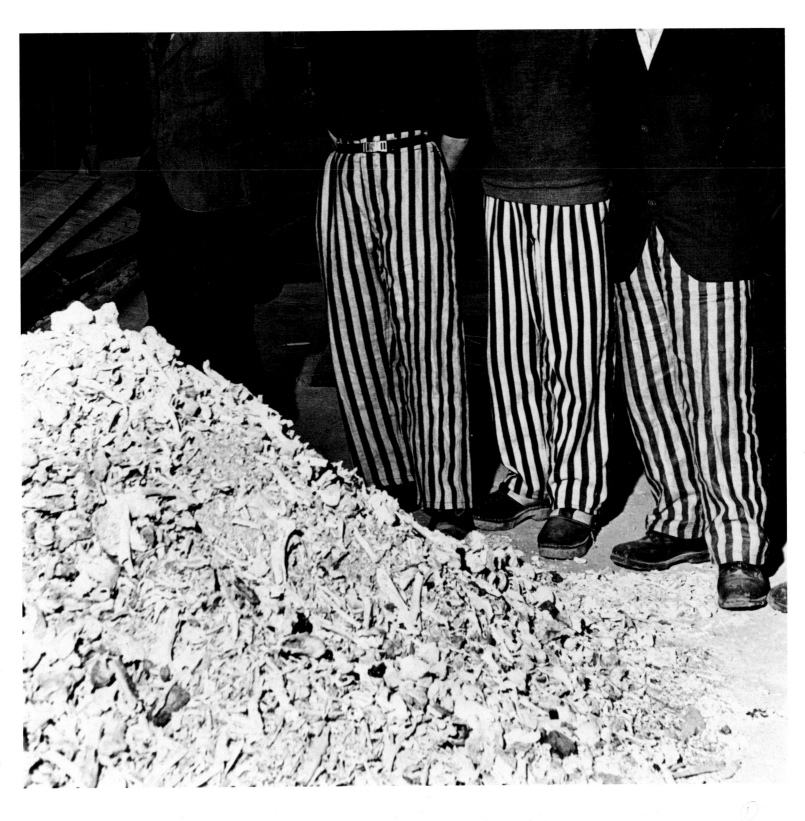

Lee Miller, Dachau, 1944.
Lee Miller Archives

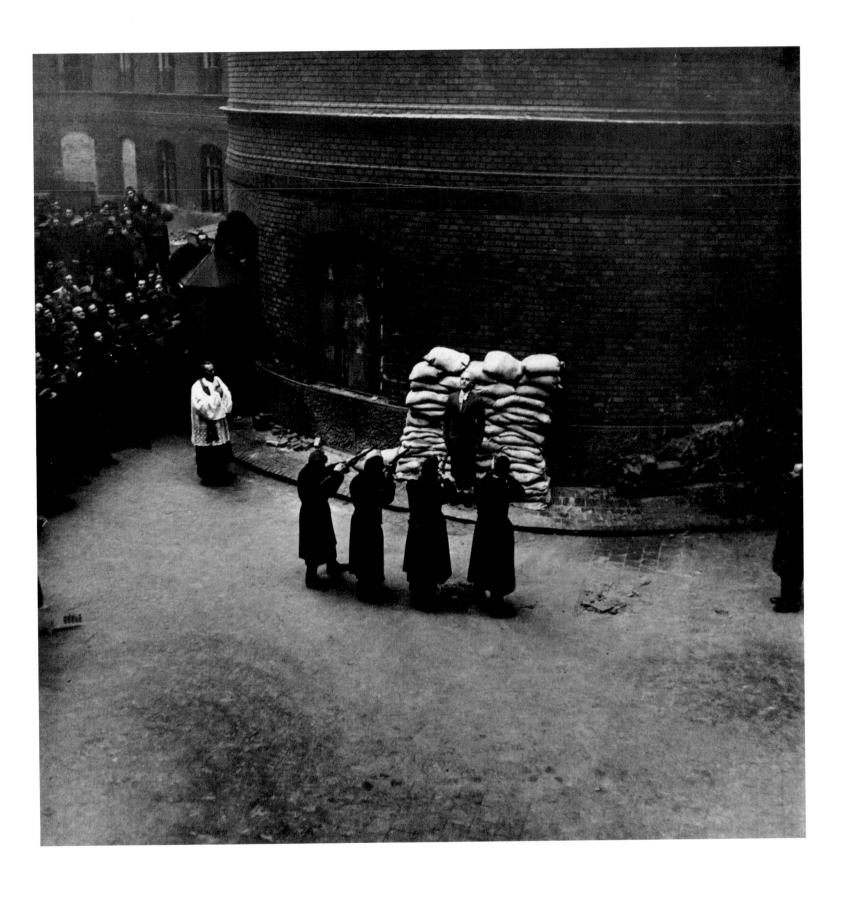

Lee Miller, Laszlo Bardossy facing the
Firing Squad, Budapest, 1946.

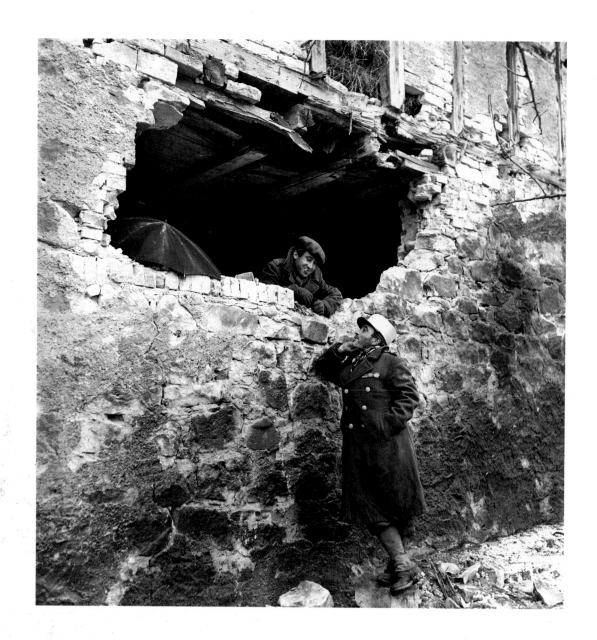

Lee Miller
Copains Discussing the War
Alsace, France, 1945
Lee Miller Archives

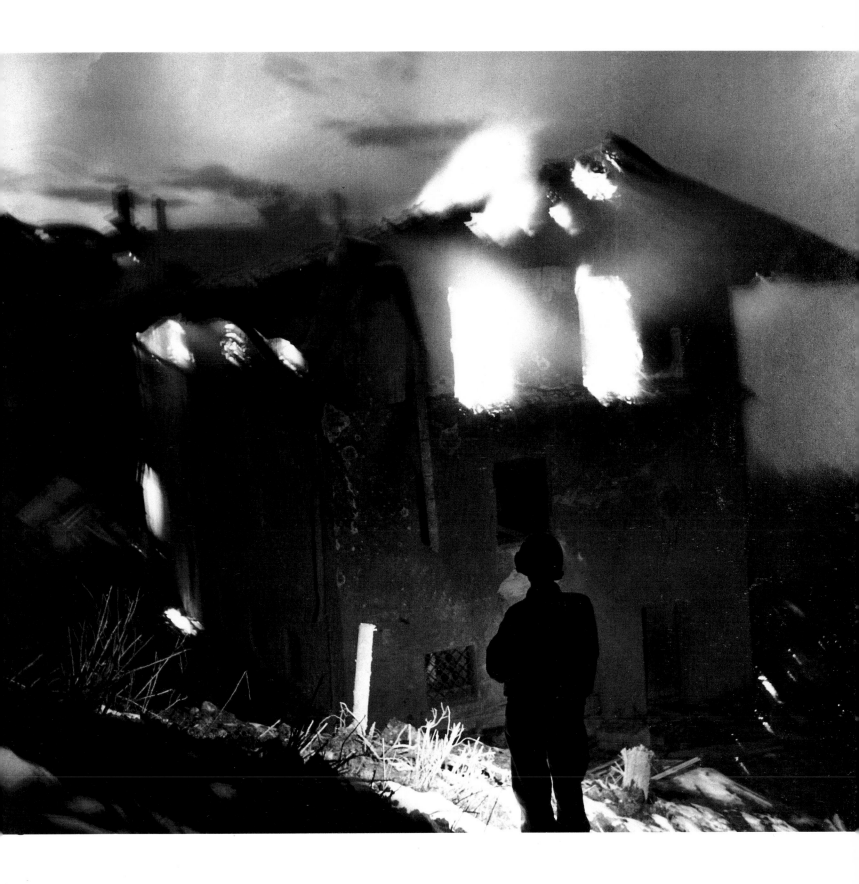

Lee Miller, Funeral Pyre of the Third
Reich: Hitler's House at Berchtesgaden in
Flames, 1945. Lee Miller Archives

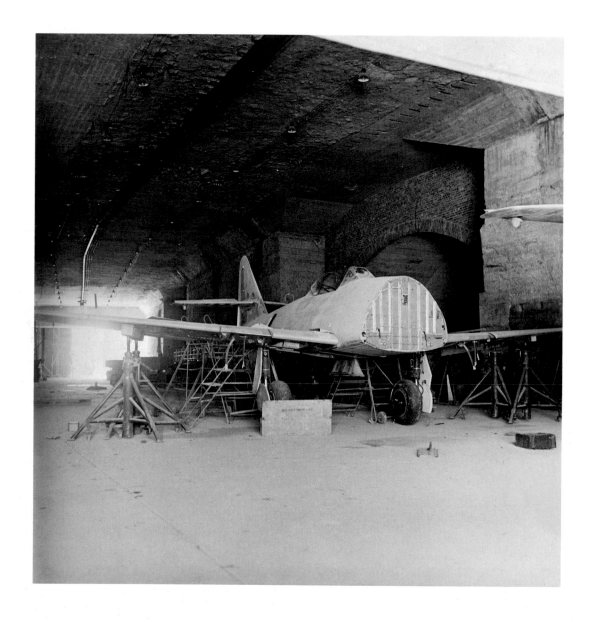

Lee Miller
Jet Plane Factory
Inside Goethe-Schiller Mountain
Near Jena
Germany, 1945

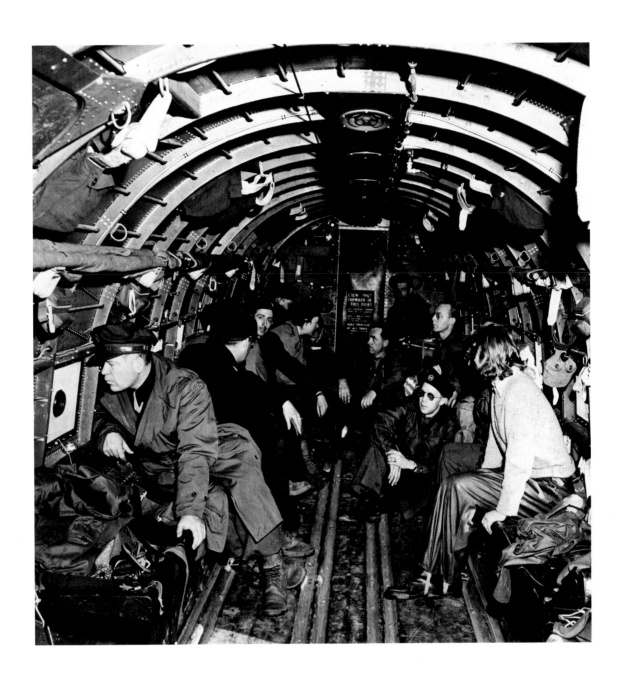

Lee Miller
Interior of C.47 Aircraft
of 312th Ferrying Squadron
USSTAF Over Germany
1945
Lee Miller Archives

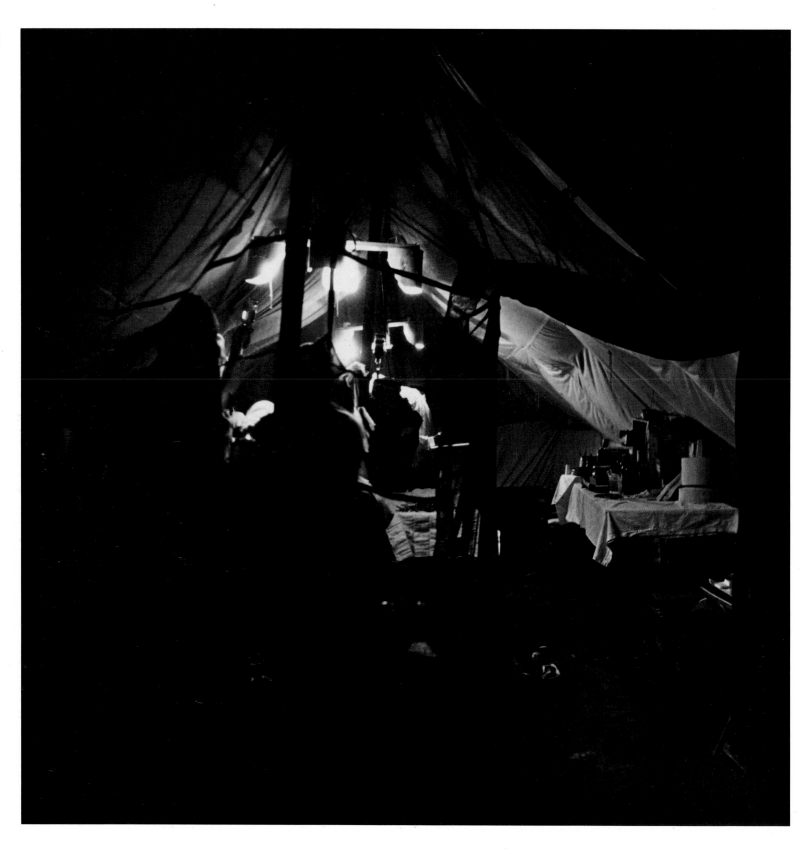

Lee Miller, Surgical Team Working in a
Normandy Field Hospital, France, 1944.
Lee Miller Archives

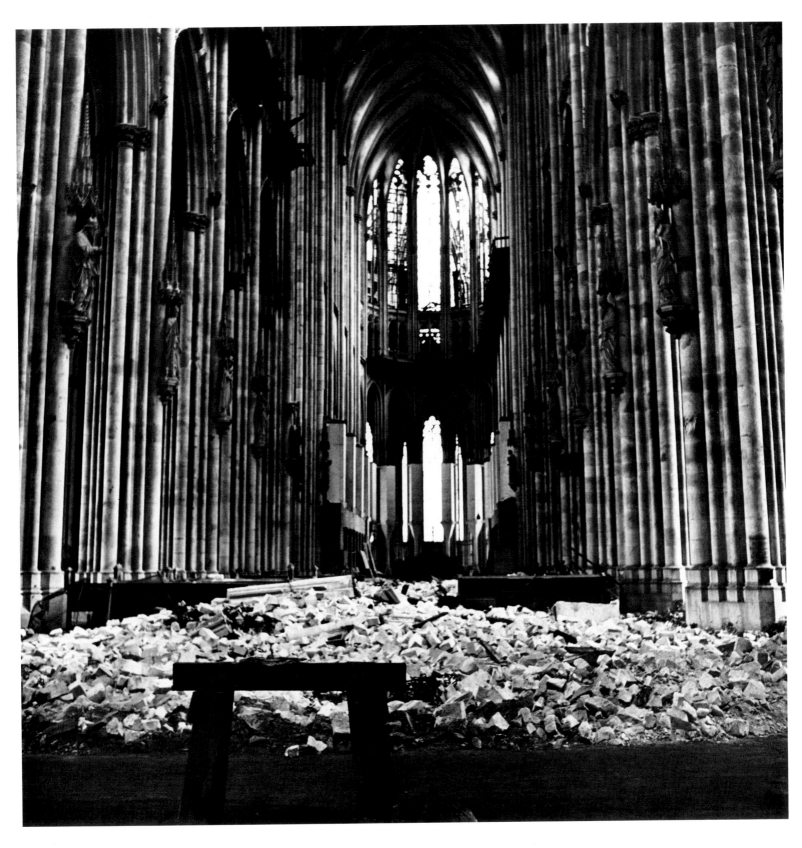

Lee Miller, Cologne Cathedral,
Germany, 1944. Lee Miller Archives

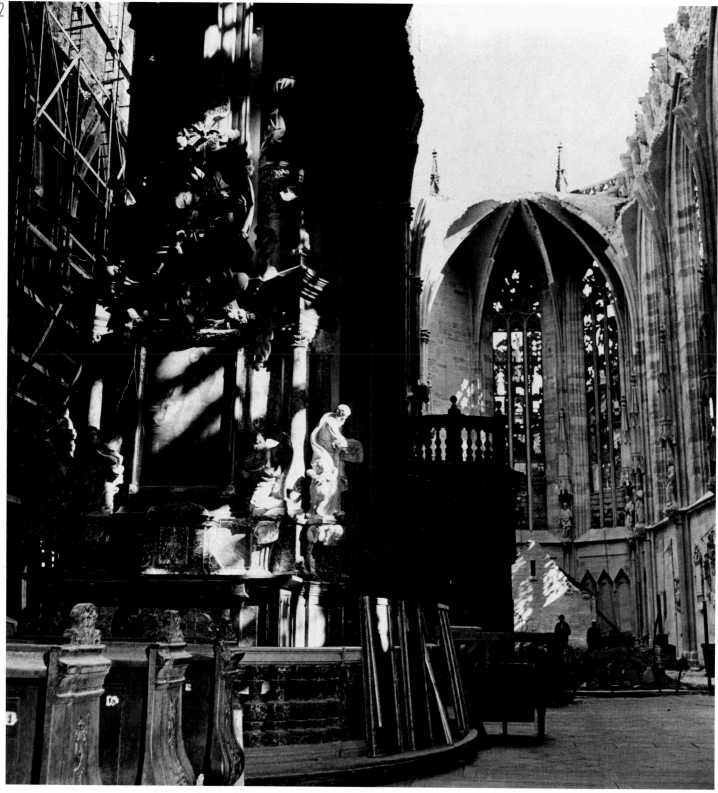

Lee Miller
St. Stephen's Cathedral
Vienna, Austria, 1945
Lee Miller Archives

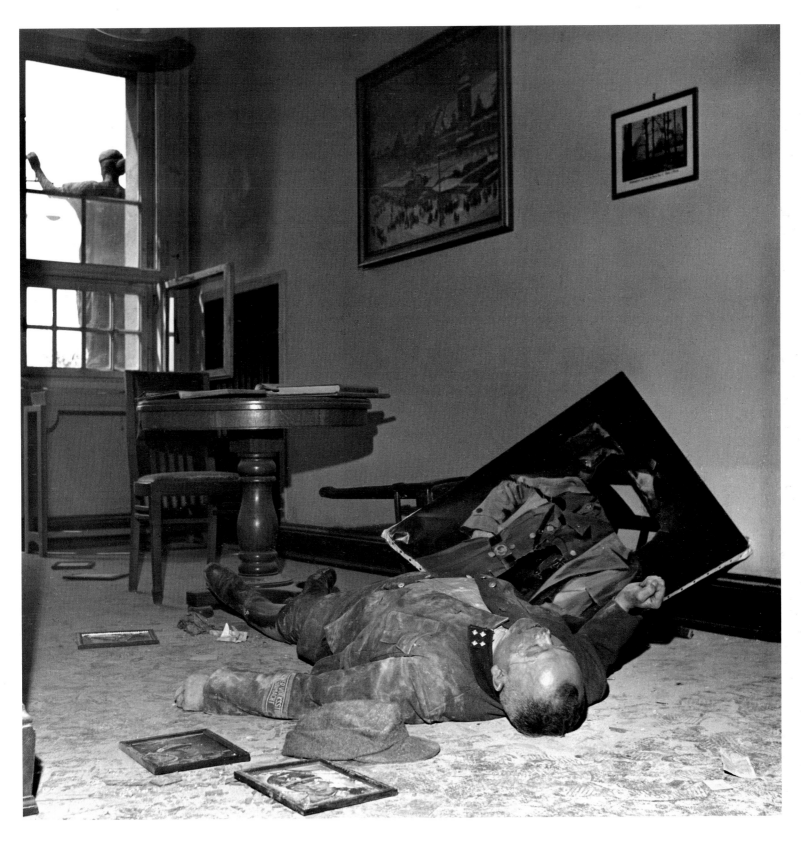

Lee Miller, Suicided Member of
the Burgomeister's Staff, Leipzig,
Germany, 1945. Lee Miller Archives

94

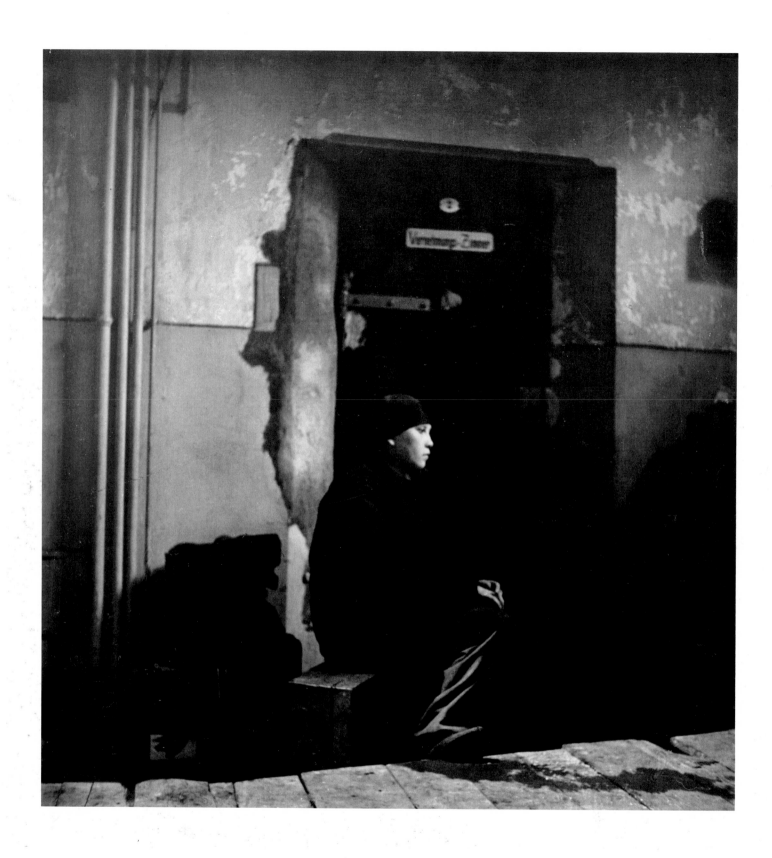

Lee Miller, Liberated Prisoner waits in
Cologne Gestapo for his Official Release,
Germany, 1945. Lee Miller Archives

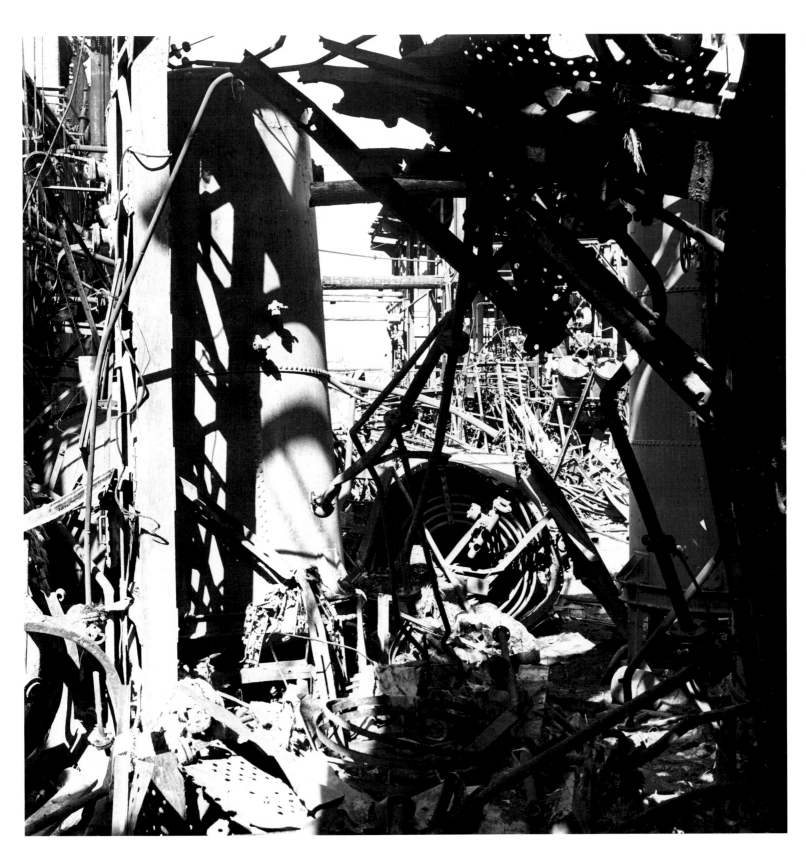

Lee Miller, Ludwigshaven Chemical
Works after Allied Bombing, 1945.
Lee Miller Archives

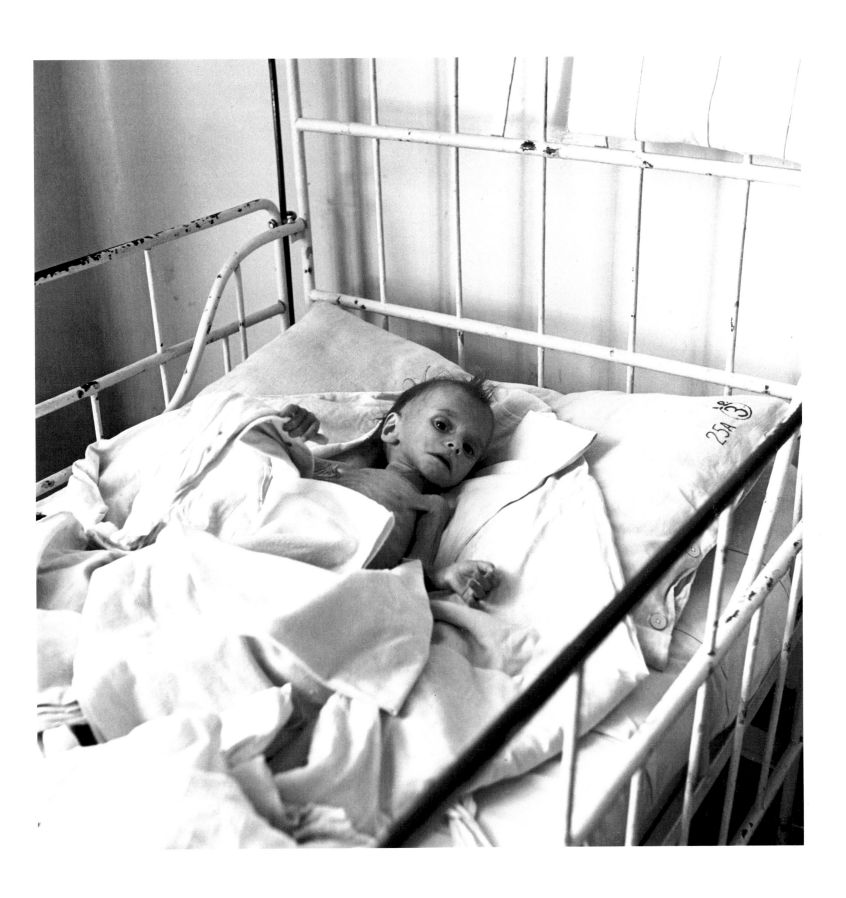

Lee Miller, Child Dying, Vienna, 1945.
Lee Miller Archives

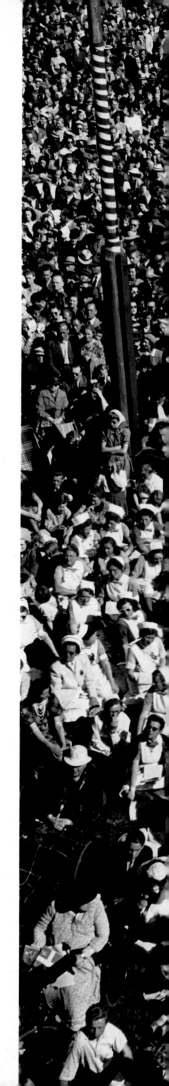

Lee Miller, Victory Celebration in the
Tivoli Gardens, Copenhagen, 1945.
Lee Miller Archives

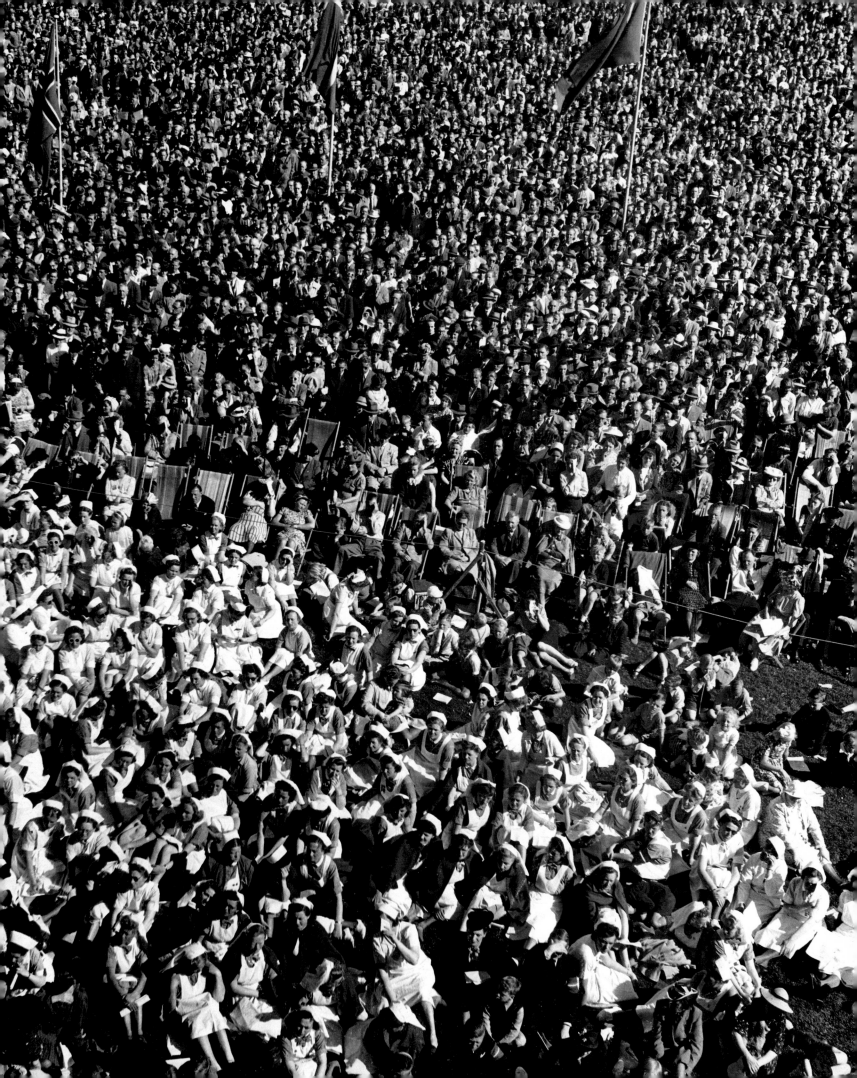

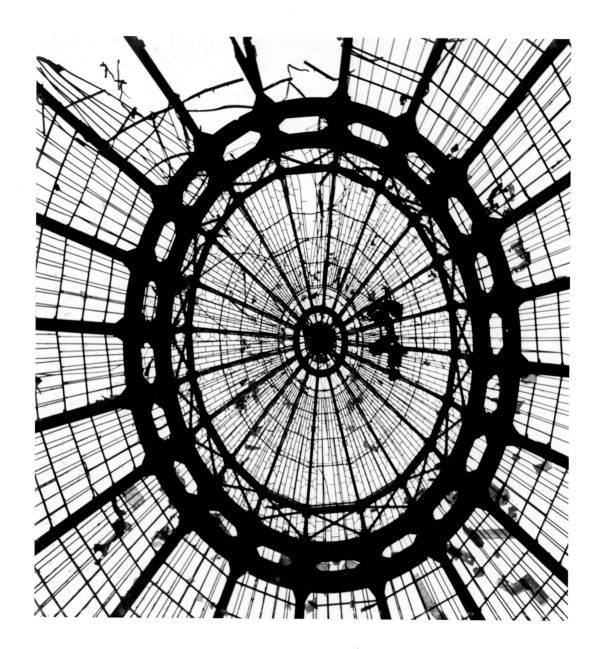

Lee Miller
Ruined Roof of Festhalle
Frankfurt, Germany, 1945
Lee Miller Archives

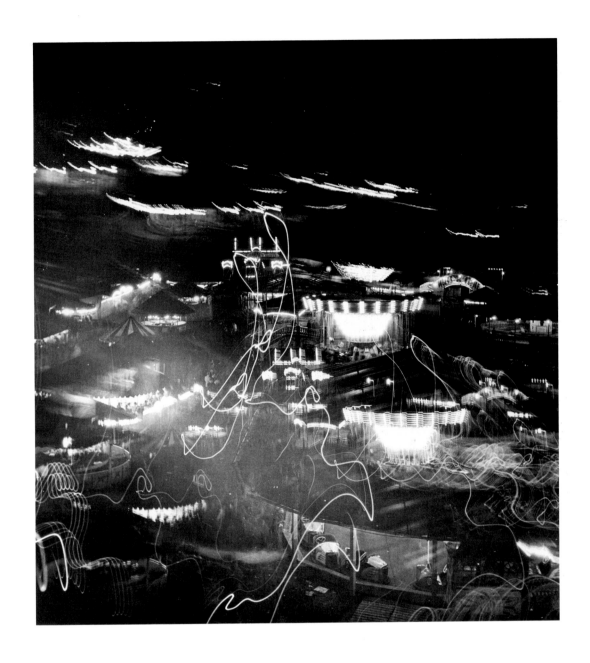

Lee Miller
Hampstead Fair
London, 1946
Lee Miller Archives

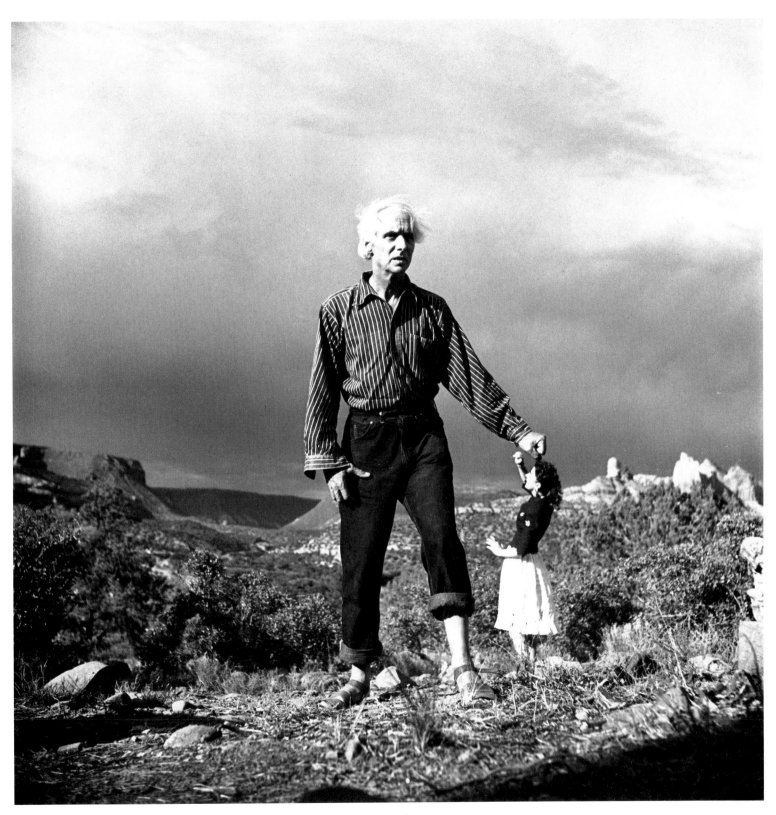

Lee Miller, Max Ernst and Dorothea Tanning,
Arizona, 1946. Lee Miller Archives

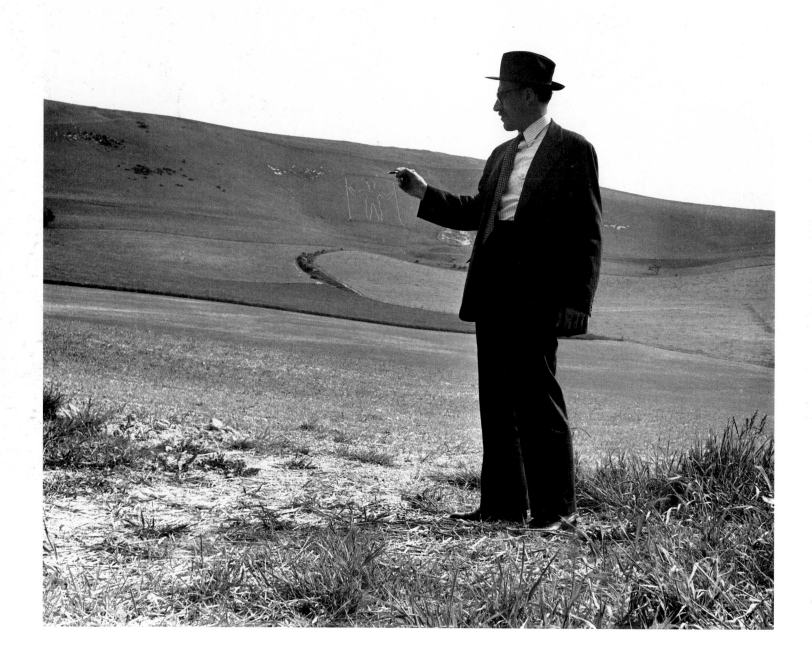

Lee Miller, Saul Steinberg at Farley Farm,
c. 1954. Lee Miller Archives

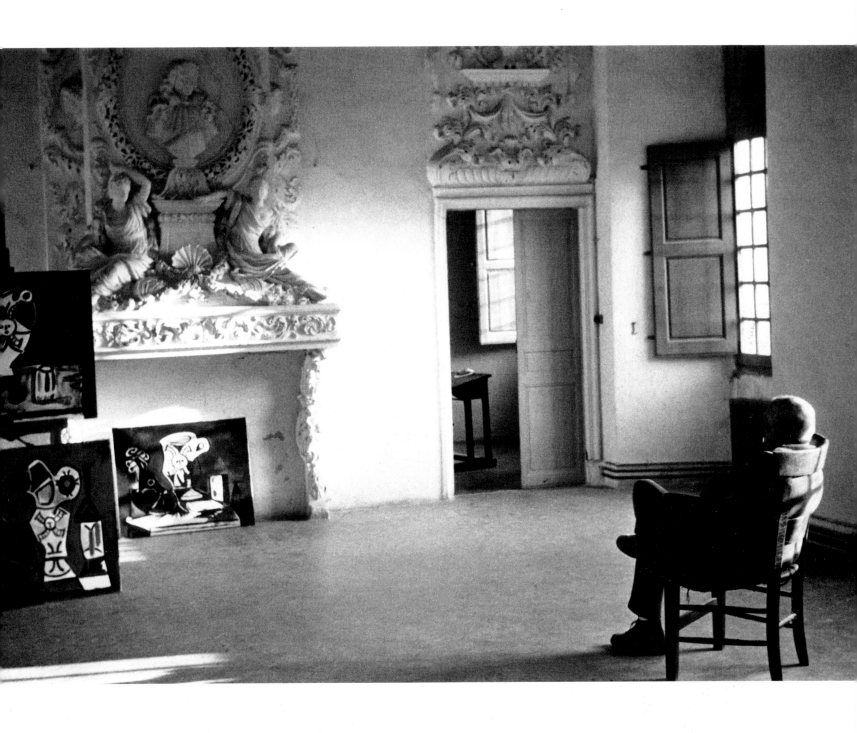

Lee Miller, Picasso at Chateau de
Vauvenargue, c. 1960. Lee Miller Archives

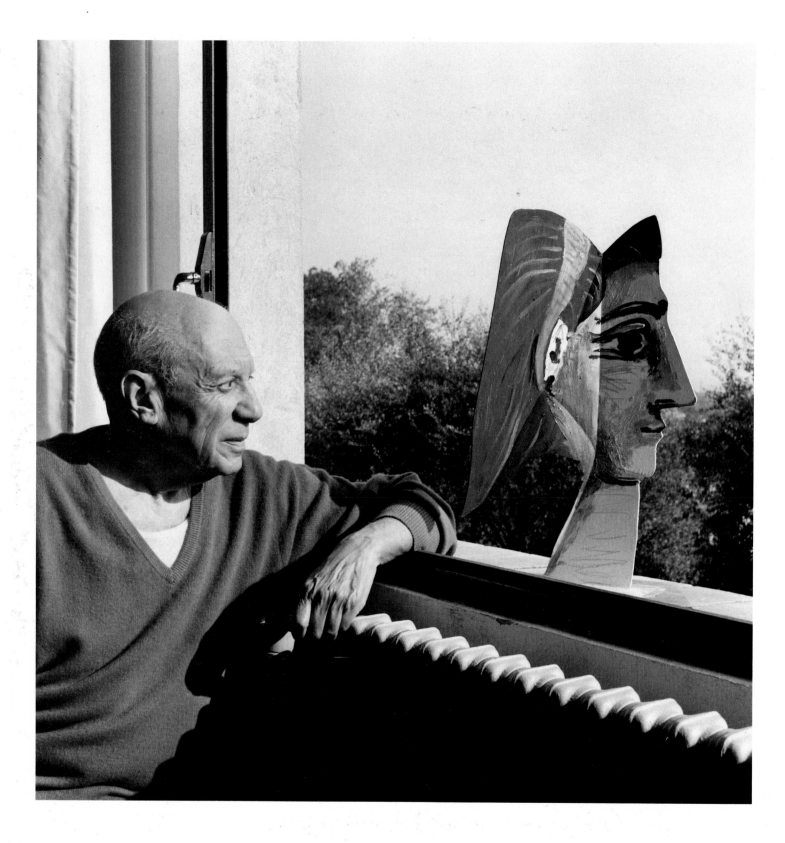

Lee Miller
Picasso and Pottery Baby
1954
Lee Miller Archives

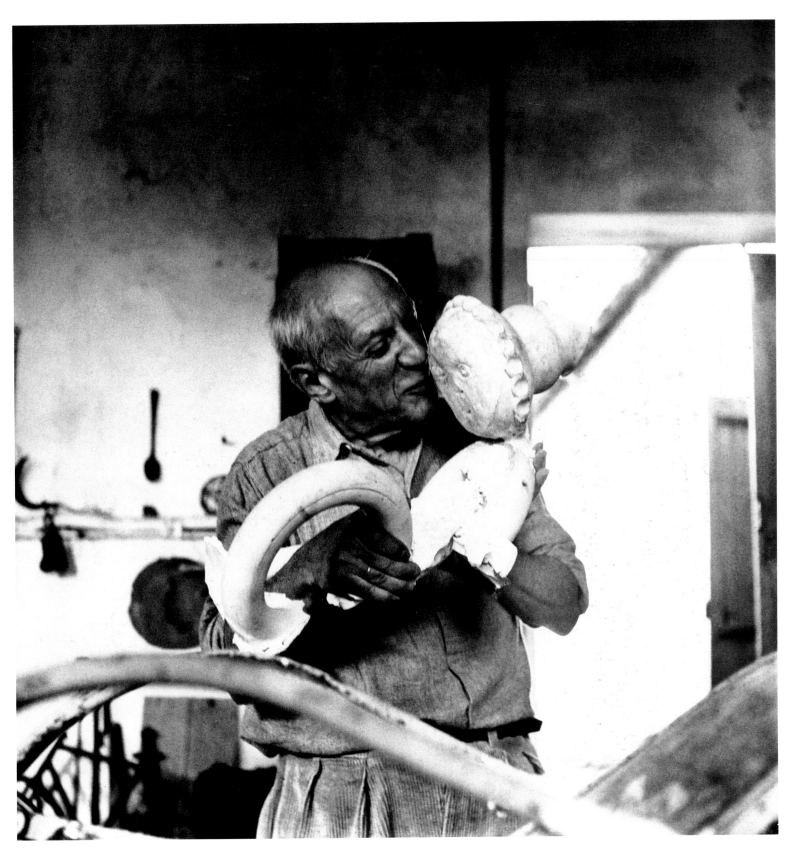

Lee Miller, Picasso, Vallauris, 1954.
Lee Miller Archives

Lee Miller, Joan Miro Visiting London
Zoo, c. 1964. Lee Miller Archives

Lee Miller, Georges Limbour and Jean
Dubuffet at Farley Farm, 1959.
Lee Miller Archives

LEE MILLER

Selected Individual Exhibitions

1933 Julien Levy Gallery, New York, USA

1978 *Lee Miller*, Mayor Gallery, London, England

1984 *Picasso's Gaze*, Photographers Gallery, London, England

1986 Photographers Gallery, London, England
Gardner Arts Centre, Brighton, England

The Lives of Lee Miller, Staley-Wise, New York City, USA

1989-90 *Lee Miller Photographer*: Corcoran Gallery of Art, Washington, D.C., (traveled to the New Orleans Museum of Art, Louisiana; Minneapolis Institute of Art, Minnesota; San Francisco Museum of Modern Art, California; International Center of Photography, New York City; Art Institute of Chicago, Illinois; Santa Monica Museum of Art, California)

LEE MILLER

Selected Group Exhibitions

1931 *Group Annuel des Photographes*, Galerie de la Pleiade, Paris, France

1932 *Modern European Photography*, Julien Levy Gallery, New York, USA

1955 *The Family of Man*, Museum of Modern Art, New York, USA (and world tour)

1976 *Photographs from the Julien Levy Collection*, Art Institute of Chicago, Chicago, USA

1977-78 *The History of Fashion Photography*, International Museum of Photography at George Eastman House, Rochester, New York (traveled to Brooklyn Museum of Art, N.Y.; San Francisco Museum of Modern Art; Cincinnati Art Institute, Ohio; Museum of Fine Art, St. Petersburg, Florida)

1978 *Dada and Surrealism Reviewed*, Hayward Gallery, London, England

1982 *Atelier Man Ray 1929-1935*, Centre Georges Pompidou, Paris, France

1985-86 *L'Amour Fou: Photography and Surrealism*, Corcoran Gallery of Art, (traveled to San Francisco Museum of Modern Art; Centre Georges Pompidou; Hayward Gallery)

1985-86 *The Indelible Image*, Corcoran Gallery of Art, (traveled to the Grey Gallery, New York; the Rice Museum, University of Texas, Houston)

1986 Musée Cantini, Marseille, France